Unsolved Murders & Disappearances

—— in ——

NORTHEAST OHIO

Unsolved Murders & Disappearances

—— in ——

NORTHEAST OHIO

Jane Ann Turzillo

THE
History
PRESS

Published by The History Press
Charleston, SC
www.historypress.net

Newspaper images on the cover are courtesy of www.genealogoybank.com.

First published 2015

Manufactured in the United States

ISBN 978.1.46711.797.5

Library of Congress Control Number: 2015952225

In many ways, all my books belong to my grandmother
Hazel Hearns Peltier (1894–1978).

She, above anyone else, gave me a love of history.
I know she would be proud of me.

CONTENTS

ACKNOWLEDGEMENTS

The best part of writing this book was doing the research and meeting the folks who ultimately gave me all the information and photographs I needed to put together *Unsolved Murders & Disappearances in Northeast Ohio*.

But before I thank all the fine librarians, family members, police, friends, et cetera, I want to express my gratitude to my commissioning editor, Krista Slavicek. Without her, this book would not be in print.

I would like to single out and thank Nicholas Durda, subject department clerk, Cleveland Public Library Photograph Collection, Cleveland, Ohio. I collected a large number of photographs for this book from the Cleveland Public Library, and he made the job easy.

Other great librarians, historians, records clerks, photo directors, archivists, policemen, cemetery sextons and morticians have all played a part in bringing the cases in this book back to light. This is my chance to thank every one of them: Amy, reference librarian, Carnegie Library, East Liverpool, Ohio; Kimberly Barth, director of photography and graphics, *Akron Beacon Journal*; Sue Clark, reference librarian, Willoughby-Eastlake Public Library, Willoughby, Ohio; Frank "Digger" Dawson, Dawson Funeral Home, East Liverpool, Ohio; Carl E. Feather, ashtabulawave.org, Ashtabula, Ohio; Cheri Goldner, special collections, Akron-Summit County Public Library, Akron, Ohio; Gary Guenther, Summit County Medical Examiner's Office, Akron, Ohio; Tammy Hiltz, reference department, Ashtabula County District Library, Ashtabula, Ohio; Ann Johnson, Canton Police Department, Canton, Ohio; Darrin Logan, president, Licking

County Fraternal Order of Police Lodge 127, Newark, Ohio; Deborah Long, Louisville Public Library, Louisville, Ohio; Gale Lippucci, adult services librarian, Willowick Public Library, Willowick, Ohio; Jennifer Lusetti, Licking County Historical Society Library and Archives, Newark, Ohio; Ken Mauro, Chestnut Grove Cemetery, Ashtabula, Ohio; Kelley Nikola, Akron-Summit County Public Library, Akron, Ohio; Maureen E. Pergola, senior records management officer, Cuyahoga County Archives, Department of Public Works, Cleveland, Ohio; Barbara Rand, volunteer, Geneva Public Library, Geneva, Ohio; staff at the Stark County Sheriff's Office Records, Canton, Ohio; Sue Schmidt, reference librarian, Orrville Library, Orrville, Ohio; Sergeant Al Shaffer, Newark Division of Police, Newark, Ohio; Shannon, records clerk, Lake County Clerk of Courts, Painesville, Ohio; and Kristine Williams, adult services librarian, Licking County Library, Newark, Ohio.

I owe a huge thanks to Linda Boyd, Roger Drake and Kermit Drake Jr. for sharing recollections with me of their sister, Anita, who has been missing since 1963.

Likewise, I want to thank James Chandler and Debi Chandler Heppe for photos and the information on the death of their grandfather.

Thanks Jennifer Popovsky, MD, for explaining medical terms on the autopsies.

The encouragement and support from my writer friends Wendy Koile, Irv Korman and Rob Sberna has meant a great deal to me. My Northeast Ohio Sisters in Crime group, especially Casey Daniels, has provided inspiration and information.

Two of the most important people in my writing career are my mentors: my sister, Mary Turzillo, and my friend Marilyn Seguin, both retired Kent State University English professors and fine authors themselves. They have stuck with me as my beta readers through six books.

I do not want to forget those period journalists whose bylines did not appear above the stories they wrote. All of us who write about history owe them a thank you.

Lastly, I want to thank my son, John-Paul Paxton, and grandsons, Nicholas and Nathan, for believing in me and being the best family an author could ask for.

INTRODUCTION

Murders were infrequent when I was a police reporter for weekly newspapers in the late '70s and early '80s, so when one did happen, it consumed a good amount of my time and gave me a large number of column inches on the front page.

One of those murders was a complicated web of betrayal and jealousy. It ended in the arrest of eleven people, including the victim's brother, an attorney, a has-been exotic dancer and a couple of two-bit, drugged-up hoods from across the country. Needless to say, the detective work on that one is legendary.

Another murder that sticks out in my mind was that of the "Millionaire Deputy," a nickname he inherited along with somewhere north of $1 million. He was shot nine times with a .22-caliber rifle from across the street while getting out of the car in his garage. It was such a baffling crime that one of the best detectives in Summit County could not bring the perpetrator to justice.

During this period, I wrote a routine three- or four-sentence paragraph for the police beat about a young Jeffrey Dahmer's first arrest for being drunk and disorderly. He had already committed at least one murder, but nobody knew about it.

But the one that hit closest to home was that of a man I had known most of my life. He was a nationally known foundations expert and well-regarded soils engineer. He was the executive vice-president of my father's contracting company. In November 1980, someone stabbed this educated, kind man to death in his Lakewood apartment. To this day, his murder is unsolved.

Murders and disappearances dig holes in the hearts of those family members and friends who are left behind to sort things out. A number of these losses never see closure even though police do their best to follow leads.

As time goes on, new cases come to the forefront and the old ones get pushed aside. They become nothing more than forgotten papers in dusty attic or basement record rooms. Maybe they have been preserved on hard-to-read microfilm.

The ten cases here are all that old. Luckily, the newspapers blasted headlines, copy and photos of the eight deaths and one of the disappearances on the front pages of Northeast Ohio newspapers. Sadly, one disappearance in these pages never saw ink at the time. Her name is Anita Drake.

Harry Beasley is remembered with photos and medals in a glass case in the lobby of the police department where he was an officer. Even his file is missing.

Charles Collins's murder crops up from time to time. Closing in on 140 years, it still fascinates because the case was closed as a suicide, and he was connected to the worst train disaster in Ohio history.

One victim lies in an unmarked grave. No one knew her name. People just called her the "Carnival Girl."

Here are eight stories of deceit, treachery and murder and two stories of children who vanished without a trace.

1

QUESTIONS LINGER ABOUT ENGINEER'S DEATH

This is a case about a single bullet fired almost 140 years ago from a six-shooter navy revolver measuring eleven inches in length. That bullet killed Charles Collins, chief engineer of the Lake Shore & Michigan Southern Railroad (LS&MS). At that time, his death was ruled a suicide. A year later, two autopsy reports by two renowned physicians from New York City would tell a different story.

Fifty-two-year-old Collins had been greatly affected by the horrific train accident that slaughtered close to one hundred people when the Ashtabula Bridge collapsed on December 29, 1876. Although he was the engineer when the iron bridge was built eleven years before the tragedy, he never gave his approval of it. He was not experienced in iron bridge construction, instead preferring masonry construction. In fact, Collins was against the bridge design, and he contemplated handing in his resignation if it went forward. Instead, he shifted its responsibility to the railroad's president, Amasa Stone, who designed the bridge and pushed for its construction.

Railroad bridges during the nineteenth century frequently collapsed. Iron bridges were especially prone to failure. The Ashtabula Bridge was built using iron Howe trusses fabricated by the Cleveland Rolling Mill Company. Stone's brother, Andros, was the president of the company.

It was Stone's experiment of sorts because most Howe truss bridges were built of wood beams and iron rods. Joseph Tomlinson, a civil engineer employed by the railroad, warned Stone that the beams were inadequate and should be reinforced. Stone's answer was to fire Tomlinson.

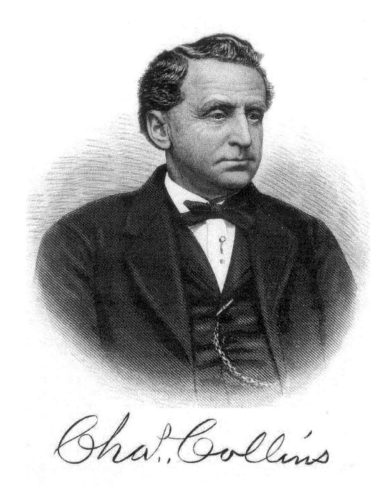

Charles Collins was chief engineer of the Lake Shore & Michigan Southern Railroad at the time of the Ashtabula train disaster. *Author's collection.*

Although Collins refused to have anything to do with designing or building the bridge, he felt some responsibility for the disaster. Tomlinson claimed Collins knew the bracing was not adequate. The bridge was in Collins's stretch of the railroad, so it was up to him to inspect it. He had the structure tested with the weight of three locomotives eleven days before the catastrophe.

The last time Collins was seen alive was at his office on Water Street in Cleveland, where he worked until nine o'clock on Wednesday evening, January 17, 1877. His wife, Mary, whom he had wed in 1856, was in Ashtabula

visiting her parents, Edwin and Miranda Harmon. Since his colleagues had not seen him in three days, they thought he had joined Mary there. Finally, when no one had seen or heard from him by Saturday morning, January 19, Isaac C. Brewer, an assistant from the Toledo division of the railroad, decided to go to his house at the corner of St. Clair and Seneca Streets.

Collins's hired man lived in quarters at the back of the house. He told Brewer he had not seen Collins for a few days and thought Collins was in Ashtabula.

Still concerned, Brewer decided to have a look for himself. Everything was quiet. Nothing seemed out of order as he walked through the house. Then he got to the bedroom. His pulse must have started to race when he realized he had to force his way into the locked room. Collins was dead. His body was perfectly stretched out on the bed. Blood had run from his mouth and ears and drenched the pillow beneath his head. His corpse was obviously in a state of decomposition, and the smell was terrible.

A revolver rested loosely in Collins's left hand. His arms were lying parallel to his thighs. The gun hand rested slightly on his left thigh. The dead man was right handed. A fully loaded double-barreled pistol was on the bed on the right. Brewer knew about these guns. Collins kept the larger one under the mattress on his side of the bed. Mary kept the smaller one under her pillow. No one seemed to wonder why both Collins and his wife slept with guns at the ready.

Was Cleveland so dangerous during that era that Collins and his wife felt the need to arm themselves? Or did they have some other fear?

Brewer backed out of the room without touching anything and called for the coroner.

It was Coroner Frederick Fliedner's opinion that Collins had been dead for thirty-six to forty-eight hours, placing the death date sometime on January 18. To him, the cause of death was plainly suicide, and he decided against holding an inquest.

Fliedner thought Collins had put the muzzle of the eleven-inch navy revolver in his mouth and pulled the trigger. He observed the revolver in Collins's left hand but must have dismissed the fact that the dead man was right handed. Three chambers of that gun were empty, but only one wound to Collins's head was evident. According to the *Plain Dealer*, Fliedner saw no bullet hole on the headboard, but there was a hole in the wall that looked to be recent and the right size. It was never verified that a bullet was found in the wall. An autopsy one year later would note a nick on the headboard of the bed and another in the closet woodwork and a piece of flattened lead on

the floor. If the hole in the wall and the ricochet bullet on the floor accounted for two of the empty chambers of the gun, what happened to the third?

The bedclothes were neatly pulled up to just above his waist. This led the coroner to believe death was instantaneous and there was no movement of the body. No mention was made of blood spatter, just the blood-soaked pillow.

An unopened razor lay on the left side of the bed near the killing weapon, and Mary Collins's derringer lay on the right side of the bed. It apparently had not been fired.

The bed chamber was in perfect order. It looked as though Charles Collins had retired as usual. His clothing was draped over a chair near the bed, and his shoes and stockings were on the floor close by. His collar with the necktie tucked inside was on a stand in front of the mirror. Curiously, his vest was found under the mattress at the head of the bed. No explanation was ever given for this. Perhaps there was something of value in the pocket?

An envelope addressed to his wife was found in a basket on a stand. Thinking it might be a suicide note, the coroner snatched it up. It was not what he had hoped. It read: "No. 10 will leave at 11:15. No. 8 at 2:45."

Fliedner noted that Collins's valuables had not been disturbed. A diamond pin and studs, which were still affixed to his shirt, as well as his money and watch, were given to a friend for safe keeping.

Collins's friends and family were in a state of shock at his death, particularly the horrific way he died. They went back over the preceding few weeks trying to make sense of it.

Collins had a sensitive nature and was deeply upset about the lives lost in the catastrophic accident. He wept openly—like a child—when he first saw the vast pile of rubble, the fires, the bodies and the thieves who preyed on the dead and weakened victims. He did not hesitate to wade into the waist-deep, frigid water of the creek where the train landed to help save as many as he could. For three weeks after the accident, he often broke down in tearful grief.

On New Year's Day at his in-laws' house in Ashtabula, he walked out onto the porch for a bit of fresh air. A passerby wished him a Happy New Year, and Collins returned the greeting. He then went back in the house and sat down to breakfast, but he did not eat. Instead, his emotions spilled out. "John wished me a happy New Year. How can it be a happy New Year to me?" he asked.

Even before the accident, Collins had complained of being overworked. "If they don't give me help in my work, I shall go crazy," he told a professional

friend. Overwork, combined with the devastation of the wreck, took its toll on him.

Collins was considered to be at the top of his profession. He was a much-admired man. The Collinwood district in Cleveland was named for him. Most of his colleagues agreed he was extremely conscientious. "There is not a better track or construction engineer in the country than Charlie Collins," said Lake Shore general superintendent Charles Paine.

Collins was born in Brunswick, New York, in 1826 to Dr. Robert L. and Amelia Collins. After receiving a liberal education at an eastern college, he graduated from the Rensselaer Polytechnic Institute and was full of promise.

His thirty-year career with the railroads began in New England, where he was in charge of work on the Boston and Albany Railroad. He came to Ohio in 1849 to take charge of locating the Cleveland, Cincinnati, Chicago and Indianapolis road. He moved to the Painesville & Ashtabula Railroad as superintendent for a short period. When the Lake Shore & Michigan Southern Railroad consolidated, he became its chief engineer and helped to locate its road. He remained with the LS&MS until the end, except for a brief time during the construction of the Mahoning Railroad.

George B. Ely, one of the directors of the railroad, told a *Plain Dealer* reporter that Collins was distraught and had lost his appetite and a great deal of sleep since the accident. In addition, Collins had been troubled by comments from the public. He thought the public put the blame on him. "Collins was a proud man, and thought more of his honor than of his life," Ely said. "He was of a very nervous temperament, and the worry and anxiety connected with the Ashtabula accident has worried him terribly."

On the Monday before his death, he had tendered his resignation to the board of directors of the railroad, but it was not accepted. The members of the board assured him that his anxiety was unfounded.

Still, it seemed to fester in his mind. He thought confidence in his abilities had been withdrawn. He vastly overrated what was said about him. He took it personally, so much so that he made this remark to Paine: "I have been thirty years working for the protection of the public, and now they turn around and kick me for something I am not to blame for, something which I have had nothing whatever to do with."

Collins's last official act was to testify before the Ohio legislative committee investigation of the disaster and to sign a document that gave all his information to a legislative committee in the investigation and prosecution of the cause of the accident.

Paine had been with Collins at his office on the Wednesday before his death. A committee of the Toledo division was leaving the next morning to inspect bridges in that area, and Collins had agreed to go with them. On Thursday morning, he did not show up to travel with them, so they assumed he had gone on ahead and was somewhere along the road. When no one had heard from him by Saturday morning, Brewer went to his house.

Collins had evidently intended to go on that inspection tour, as his travel bag was packed and sitting in the bedroom. A new pair of boots were not far away.

There are conflicting stories about his state of mind that last day he was seen alive. His colleagues who were with him on Wednesday saw nothing in his demeanor to give anyone cause for concern. Yet Brewer had stayed with Collins on the Monday and Tuesday night before. Was he afraid to leave him alone?

News of Collins's death spread fast throughout the railroad. A number of his closest associates came to his house looking for information. Only a few were allowed in to take charge of his body and valuables.

While one newspaper article said the police questioned the suicide finding, another said the police were not interested. Apparently, no record survives to give a decisive answer.

On the day of Charles Collins's funeral, a large group of people wishing to pay their respects started to gather in front of his house as early as ten o'clock in the morning. Only the family, officers of the Lake Shore Railroad, prominent businessmen and his closest friends were permitted inside the house, where his casket was surrounded by standards of roses, jasmine and calla lilies. The service, which included selections from both the Old and New Testaments of the Bible and the hymns "Nearer My God to Thee" and "Jesus Love of My Soul," was conducted by Reverend H.C. Haydn.

Twelve close friends and colleagues acted as pallbearers to carry the casket to the hearse. The cortège then made its way slowly through Cleveland streets to Union Depot, where a special train sat in wait to carry Collins on his last journey to Ashtabula. The conductor was F. Paige. The family, all the Lake Shore & Michigan Southern Railroad officials and a large number of citizens accompanied the casket. A number of cars were needed to carry the mourners. Among them were the parlor cars America, Northern Crown and Stella. The train was pulled by Rapidan, one of the oldest and most reliable engines on the road. One of the longest tenured employees, engineer Nick Hartman, had the honor of being at the throttle.

Collins is interred in a mausoleum at the Chestnut Grove Cemetery in Ashtabula not far from the graves of the nineteen unidentified victims who

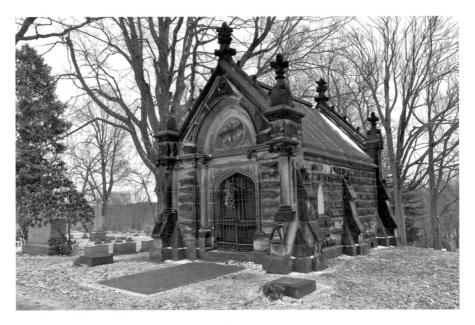

The mausoleum where Charles Collins is buried in Chestnut Grove Cemetery. *Courtesy of Carl E. Feather.*

died in the wreckage. Interestingly enough, Mary Collins bought four lots at the cemetery on January 19, 1877, one day after her husband was presumed to have died and one day before his body was discovered. The mausoleum is built on these lots. Besides Collins, it holds the remains of Mary Collins, Kittie G. Harmon and Miranda and Edwin Harmon, Mary's mother and father. Kittie is listed on Find-a-Grave as Collins's granddaughter, which is unlikely because Charles and Mary had no children. The building was quite beautiful, with black-and-white terrazzo floors and stained-glass windows when it was built, but time has taken its toll on the structure. Now, it's in need of repair.

Isaac C. Brewer, having been the first to witness the death scene, never believed the suicide theory. George L. Converse, chairman of the joint committee of the general assembly to investigate the accident, thought Collins had been murdered. His family and several of his closest friends were adamant that it was murder. They all thought someone had been hired to kill Collins to stop him from testifying before the legislative committee.

A year later, Collins's body was exhumed, and his skull was sent to Dr. Stephen Smith, a surgeon at Bellair and St. Vincent's Hospitals in New York City. Smith was also a professor of surgical jurisprudence at University

Medical College in New York. It was his job to give a full and unbiased examination of the skull.

On June 3, 1878, Smith issued a fourteen-page, handwritten report. In looking at the openings where the bullet entered and exited the skull and the fractures that it caused, Smith's assessment was different than that of Cleveland's coroner, Frederick Fliedner.

Whereas the Cleveland coroner decided Collins had put the gun in his mouth and shot up through the roof of his mouth, Smith discovered the ball had actually entered the skull toward the back of the head approximately four inches behind the left ear and had exited approximately five inches above the right ear, still toward the back of the head. Traces of lead were evident at both holes. The impact pushed Collins's brain forward, fracturing the bones behind his eyes. This may have caused what was thought to be a blow to the head.

The opening on the right side proved that the ball escaped the skull, evidence that the gun had been held four or more inches away. Smith stated that all experiments made with a six-shooter navy revolver eleven inches in length uniformly found that when the muzzle of that type of gun was held close to the skull, the ball did not escape the scalp. Although it may have made a fracture in the bone, it would fall back into the cavity of the skull. Because the ball was eventually found, it was fact that the ball had exited Collins's head. At the time of Collins's death, there was little mention about whether Fliedner found the ball, but Smith stated there were dents in the mahogany headboard and woodwork of the closet, which was in proximity to the bed. A flattened ball was found on the floor just below the closet.

In Smith's opinion, the wound was not immediately fatal because its path "did not involve vital parts of the brain, nor large blood vessels."

Collins was right handed, and the navy revolver was found in his left hand. Smith contended that it would have been close to impossible for the dead man to hold that size gun in his nondominant hand at an angle at least four inches away from the spot where the ball entered his skull. He would have had to strongly avert his head. Even so, he could not see where the muzzle of the gun would have been pointed. Smith further stated that, when the gun recoiled, Collins's hand would have fallen over the side of the bed, and the gun would have been thrown some distance from the bed.

Smith also noted that the body and bed linens had not been disturbed, which was inconsistent with a suicide. He described the different conditions a body might suffer at gunshot suicide—shock, paralysis and unconsciousness. These would have led to cerebral irritation, and the

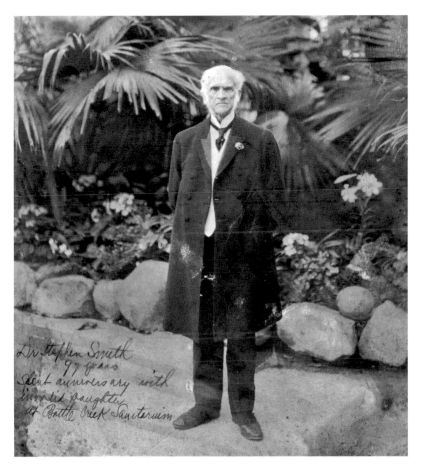

Dr. Stephen Smith, University Medical College, New York, performed Collins's autopsy. *Courtesy of The Lillian and Clarence de la Chapelle Medical Archives at NYU.*

body would have suffered spasms. None of that would be consistent with smooth bed linens and a body in a natural position.

At the end of the document, Smith stated, "My opinion is that Mr. Collins came to his death by a shot wound inflicted by other hands than his own."

Dr. Frank Hasting Hamilton, a colleague of Smith's at the medical college, concurred, saying that it was highly unlikely that a right-handed man would use his left hand to shoot himself when nothing appeared to be wrong with his right hand. He added, "If Mr. Collins was rendered immediately unconscious and was completely paralyzed and remained so until death (which was probably the fact) the position of the left arm and hand and of the revolver is not satisfactorily explained upon the suicide theory." He

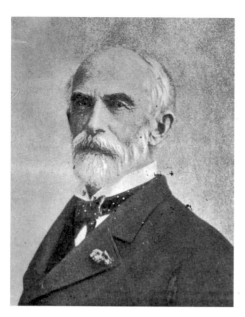

Frank H. Hamilton, AM, MD, LLD,
University Medical College, New York.
Courtesy of The Lillian and Clarence de la Chapelle
Medical Archives at NYU.

felt Collins's life "was taken by another person while he was lying asleep in his bed." Hamilton also felt Collins's left arm, hand and the revolver were arranged after death.

The two autopsy reports were not made public at the time, maybe to protect whoever killed Collins and to stave off any more scandal from the accident.

Both autopsies were found tucked away in a box full of documents bought at an auction in the early 1900s by a woman named Mrs. Terrill. Her son, William Terrill of Geauga County, found them and gave them to Alice Bliss of the Ashtabula Historical Genealogical Society around 1975.

Drs. Smith and Hamilton answered the question of whether Collins died by his own hand or that of someone else. The question that still remains is who shot that bullet from Charles Collins's eleven-inch-long navy revolver?

2

NO LEADS TO
TEACHERS' SLAYER

On Thursday, February 17, 1921, fourteen-year-old Edward Ritenour; his sixteen-year-old sister, Edith; and six year old Ralph Pickard saw something they probably would never forget. It was a little before 8:30 a.m., and they were on their way to school in Parma. The children were trudging west through icy mud along a lonely stretch of Bean Road, now Ridgewood Road.

Something that looked like a bundle lay on the embankment. Being young, their curiosity prodded them to clamber up and investigate. As they got closer, they recoiled in horror and fear at the grisly scene. Two women's bludgeoned bodies were sprawled on the pathway in front of them.

The three children raced the quarter mile to their school. Instead of the warmth and safety of their classrooms and teachers, they found other students waiting outside in the cold for the two temporary school buildings to be opened. They blurted out what they had seen to their friends. The older students quickly put two and two together. Their school had always been open in the mornings when they arrived. Their principal, Miss Louise Wolf, and teacher, Miss Mabel Foote, had never before been late to unlock the buildings.

The students cried for help from Frank Owen, a carpenter who was working on the new high school across the street. He and the students made their way back to Bean Road where the horrible scene presented itself. Owen's wife, Lottie, was the school principal's sister. As soon as he saw the victims, he knew one of the bodies was his sister-in-law.

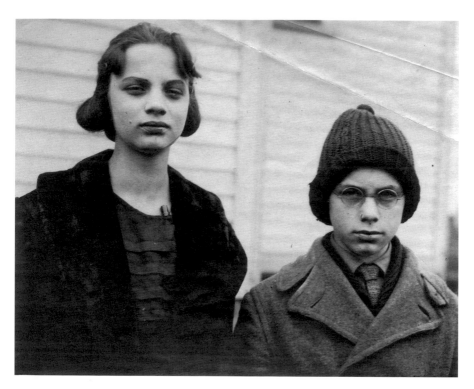

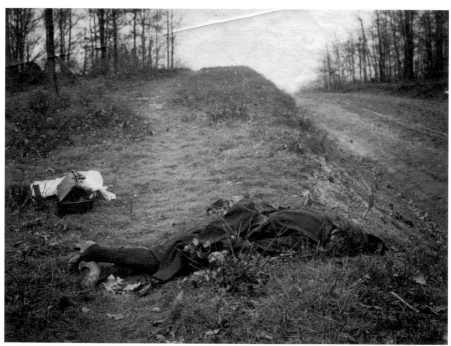

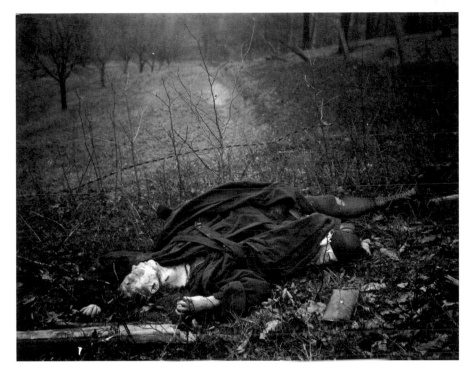

The body of Mabel Foote. *Courtesy of the Cleveland Public Library.*

Opposite, top: Edith and Edward Ritenour found the bodies of Louise Wolfe and Mabel Foote. *Courtesy of the Cleveland Public Library.*

Opposite, bottom: The body of Louise Wolf and a satchel carried by Mabel Foote. *Courtesy of the Cleveland Public Library.*

Parma police chief Frank W. Smith was faced with the most hideous crime in Parma history. The school's thirty-eight-year-old Louise Wolf was visible from the roadway, lying facedown on the embankment path. Her face was beaten almost beyond recognition. Her pocketbook was underneath her. One of her rubbers was lying beside her. The other was still on her foot.

Twenty-four-year-old Mabel Foote's body was farther back from the road, near a fence that bordered an orchard. She was on her back with her arms flung above her head, her hands tightly clenched. She, too, had been badly beaten. Her pocketbook, containing a small amount of change, was found between the two bodies. A few feet away from Louise's body was Mabel's black travel bag; its contents, which included some clothing, were scattered in the mud. An umbrella was near her body. It was bent and the tip was broken off.

Although the school day was over at 3:30 p.m., Mabel and Louise stayed after to grade papers and clean the classrooms. Then, they walked the same two-mile route together every day to catch the 5:30 p.m. dinky (streetcar) at the intersection of Bean and State Roads. A man who lived directly across the street from the high school told police he had seen Mabel and Louise leave the building about 5:00 p.m. on Tuesday. Because there were no houses in the vicinity and it was a lightly traveled road, Louise and Mabel were not seen again until their bodies were discovered the next morning.

A four-foot section of one of the fence posts, along with a bundle of bloody saplings, was found nearby. Dark hair from Louise and light hair from Mabel clung to the end of the post. The post was bent almost in half. Chief Smith figured it had been wielded with both hands for enough power to bend it in half and crush the women's skulls.

Both Louise's and Mabel's knuckles were bruised and discolored, evidence they had put up a fight. Heavy footprints in the mud told the story of the women's desperate struggle. Early on, some police investigators thought there were two attackers, but Smith thought the crime was perpetrated by one man. He figured if there had been two men, they would have overcome the women more easily.

The assault began in a gully along the road. The women had fought their attacker every inch of the way up a six-hundred-foot grade. Police thought that as the assailant grabbed one of the women, the other tried to help her by using sticks and stones against the attacker. It looked like one of the teachers had used the umbrella to defend herself or her friend because of its broken tip. It was apparent that the women would not leave each other.

Mabel's watch was located 150 feet away. It had stopped at 5:15 p.m., leading police to believe the attack happened at that time. A handkerchief had been trampled into the mud.

Matted-down, blood-spattered grass indicated the most brutal part of the battle had taken place near a wire fence that bordered the orchard. Two fence posts were broken off from what police thought was the bodies being thrown against the fence.

From what police could tell, Mabel fell first near the fence, and Louise continued to fight for her life but was finally beaten into unconsciousness not far from Mabel. The murderer then returned to Mabel to continue his attack on her.

A blood trail from Mabel's body to her overnight case led police to think that she regained consciousness long enough to wipe the blood from her face

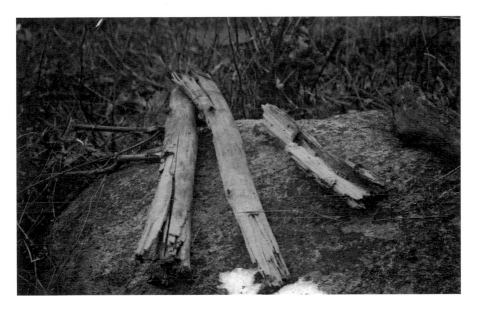

Fence posts, thought to be the murder weapons. *Courtesy of the Cleveland Public Library.*

with a nightgown from her bag. She most likely lost consciousness again and died either from blood loss or exposure to the cold.

Deep tracks in the frozen mud clearly showed the murderer's running retreat. He jumped down onto the road bed and dashed several hundred yards, then turned into the woods on the south side of the road.

Chief Smith brought in police dogs to track the killer, but the dogs were of little help. Scent from the footprints had been destroyed in the rain from the night before. Gusting winds had blown away odors from the death scene and may have taken other evidence with it.

Smith was stumped when it came to motive. Neither woman had been sexually assaulted. Robbery did not seem to be a motive because both were still wearing their jewelry—one of the women even had a diamond ring. Looking into the two women's backgrounds was no help. Neither seemed to have any enemies.

This was Mabel's first year teaching. Having graduated from Baldwin-Wallace in Berea the year before, she was full of promise. She was a pretty young woman who still lived with her parents, Joel Lindsey and Ella, and siblings on Schaaf Road in Brooklyn Heights. She had one sister, Millie, and three brothers, Joel, Kenneth and Aaron. When she did not come home that evening, her father was not concerned. She often went to stay the night with her cousin, Mary Shankford, who lived on Devonshire Road, he said.

Mabel Foote was a teacher at Parma school. *Courtesy of the Cleveland Public Library.*

Louise had suffered tragedy early in her life when both her parents died unexpectedly. She and her siblings were farmed out to relatives or adopted. In spite of hardship, she completed her education and became a teacher. She shared a house with another woman, a common and economical custom for unmarried women at the time. She had taught at the school for two years before becoming the principal.

Smith evaluated the area. Bean Road was up and down with steep hills, and there were no houses on this section. Heavy woods and an orchard bordered both sides of the road. A quarter mile east of Ridge

Louise Wolf was the principal at Parma school. *Courtesy of the Cleveland Public Library.*

Road was a gully. It was the perfect place to commit such an atrocity and have it go unnoticed.

Every able-bodied man who could get away from work set out to comb the woods. A shack built by a real estate company sat back off the roadway, and the searchers wondered if the murderer may have hidden there and waited for Mabel and Louise to walk past. Footprints led police to an abandoned chicken coop several hundred yards north of Bean Road. Detectives thought the murderer may have waited in the run-down coop until dark to make his getaway.

A pool of blood inside the coop had been covered over with bricks and sticks. Was the blood from the murderer? Or was the blood from chickens butchered years before?

Twenty feet from the coop was a working water pump. Did the murderer draw water to wash the blood off himself? Did he stop there to tend to wounds that he received during the fight with his victims?

Close by, a shallow stream meandered icily through the farmland where the killer could have rinsed blood from his hands and face. Searchers examined the frozen ground, but it was impossible to tell if he had crouched down next to the stream.

Charles Foote, Mabel's uncle, was of the opinion that murderers sometimes return to the scene of the crime. With this in mind, he frequented the murder scene night after night, tramping through the woods by flashlight beam, hoping to run into his niece's killer. His nightly visits made neighbors who lived near the wooded area nervous. His vigil produced nothing.

The victims were laid to rest four days after their murder. Mabel Estelle Foote's funeral service was held at the Pearl Road Methodist Church. She was interred in her family's private cemetery. Services for Louise Wolf were held at a private home. Detectives attended both services, thinking perhaps the killer might want one last look before the women were buried.

"Everything must be done to catch the murderer," Prosecutor Edward C. Stanton told the *Cleveland Plain Dealer*. "This is the most cold-blooded and carefully planned outrage that I have ever had called to my attention."

Before long, the Cuyahoga County Sheriff's Department, under Charles B. Stannard, joined the investigation, and Cleveland detectives also became involved.

Stanton asked three county detectives to investigate the murder. Detectives James Doran, George Keller and Albert Saukoup got their first look at the scene four days after the murder. They walked the woods on both sides of the road, but by then, the killer's tracks—and probably any evidence—had been trampled by all the searchers.

Doran and the other two detectives agreed with local police that there was only one murderer and that he knew the area and habits of Mabel and Louise well. Doran called the killer a moron. "His crimes almost without exception are carefully premeditated." It is interesting that he equated a "moron" with the capability of premeditation, never mind that if the killing was planned, the murderer would have brought a weapon with him instead of using fence posts. "What makes it more difficult is that this particular type of pervert is noted for extreme cunning which seems to accompany his insanity."

All of the the investigators and the prosecutor agreed that this type of murderer traveled alone. They figured that he either lived in the area or had

lived in the area at some point and was thoroughly familiar with Mabel and Louise's route to the streetcar.

Searchers continued to comb the woods looking for any kind of lead—a button ripped from the killer's coat, a bloody handkerchief, a torn piece of cloth caught on the barbed-wire fence—but the attacker left nothing behind.

Cuyahoga County sheriff's deputies and city policemen latched on to the theory that the killer was mentally deficient. They visited every farmhouse within a two-mile radius of the murder scene, asking if there were any "half wits" in the neighborhood. They questioned every workman in the area.

Two men who lived in the neighborhood came under police suspicion early on because they could not give a satisfactory account of their time on the evening the teachers were murdered. They had no marks on their faces or hands indicating they had been in a fight. After an interrogation, they were finally released.

Cleveland police detained two other men who admitted to visiting a third man who lived near Bean and Ridge Roads, but there was nothing to connect them to the murder of the two women. Local police talked to anyone they deemed suspicious—farmhands, men at a workers' camp and even area residents—dropping their questioning only when convinced their target had nothing to do with the crime. Every stranger who entered the township was subjected to police questioning. Any man with so much as a scratch on his face or hand was picked up and rigorously interrogated, necessitating he prove his innocence.

Parma township trustee J.D. Loder told police he had seen two strange men pass his house around dinnertime on the night of the murder. He remembered it because their clothing was mud spattered and they were bareheaded.

A woman who lived about two miles from Bean Road told Sheriff Charles Stannard that a strange man had been peeking in her windows the day before the killings. She said he had a club with him. She asked him what he was doing, and he grunted his reply.

Investigators followed every tip they felt had merit. Consequently, they went on countless wild goose chases. "We will probably go on many more," Sheriff Stannard said. "There is nothing too foolish to follow up. Any clew [*sic*], no matter how meager, we will welcome and follow to the end," he told a *Cleveland Plain Dealer* reporter.

Meanwhile, the Southwestern Civic Association, the Civic Business Men's Association, the Parma School Board, the Independence rural district school board and the Brooklyn Heights School Board met with county commissioners and urged them to post a $5,000 reward for information

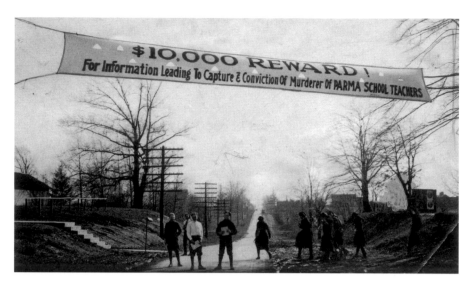

Students from the Parma school under a reward banner. *Courtesy of the Cleveland Public Library.*

that would lead to the capture and conviction of the killer. The reward was eventually upped to $10,000.

Stanton told the papers, "The man who committed this crime is still at large and the community will not rest until he is apprehended."

At one point in March, Sheriff Stannard sent three of his deputies house to house to fingerprint Parma men, which showed just how desperate police were. However, many citizens went along with it.

In April, police received a letter from someone who claimed to have witnessed the murders. The letter gave the name of the perpetrator and was signed "A Lorain Avenue Citizen." Investigators hunted the writer down. During questioning, he admitted to Stannard and Detective John Shipley that he sent the letter and gave his own name as the murderer.

A Bertillion expert said fingerprints found on one of the teachers' books were similar to those of the letter writer. He was recognized as a peeping tom, and three boys from the Bean Road neighborhood said they had seen him in the vicinity both before and after the murder. Another citizen came forward and identified him as the man who had stood and watched the construction of a drain pipe in the vicinity of the murder on the afternoon before the crime.

Shipley and two other detectives took him to the scene, where he was able to reconstruct the murder in a detailed statement. They gave credence to his confession, even though he was obviously not mentally stable. Police claimed his family had burned his bloodstained shoes and used strong stain removers

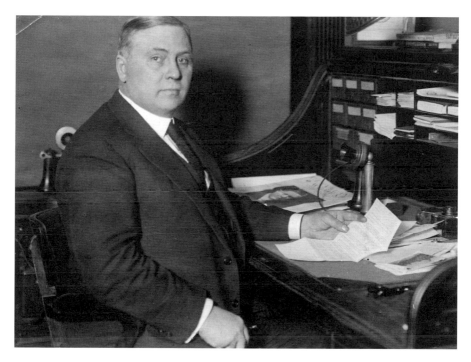

Parma police chief Frank W. Smith. *Courtesy of the Cleveland Public Library.*

to get blood out of his clothing. His family denied any of this. They said that his confession was a result of his mental state. His name was not made public.

Stannard did not think he was the killer. "I believe he reconstructed the murder from what he read in the papers and from his own imagination," the sheriff told the newspaper.

Alienists (psychiatrists) agreed with Stannard. They assessed the man and told police his mental capabilities were that of a child, and they were convinced he had nothing to do with the crime.

Special attention was given to a conversation between Mabel and Louise that was overheard by a couple of their students. Apparently, Mabel had met a stranger along Bean Road the day before the murder. It sounded innocent enough. He had just asked her where he could catch the streetcar, but there was no description of the man and nothing to identify him. It was another empty lead.

As time went on, more and more men were subjected to police interrogation. Detectives investigated whether two men lodged in the Ohio State Penitentiary had anything to do with the murders. They found it was another waste of time.

The murder was so widely publicized that it brought a number of bizarre characters out of the woodwork. Akronite Mae Patterson, who called herself a private detective, claimed to have divine guidance. She told the *Cleveland Plain Dealer* she had a vision: "Miss Foote's spirit came to me. She held out her arms to me in a pleading manner and said, 'Get that man.'" The vision left her before a name was revealed.

Investigators were hopeful when Fred Goetling claimed responsibility for Mabel's and Louise's murders. He had a criminal record dating back to 1905 and was arrested in 1923 for the axe murder of Harry Keim in Cleveland. He was found to be insane and taken to the Lima State Hospital. Although Goetling looked promising for the teachers' murders, his statement turned out to be another false confession.

Ten years later, police were still collecting evidence, but none of it was revealed to the public. Circumstantial evidence came to light through a private citizen who wanted to know if the reward offer was still good. The evidence was not made public, but whatever it was, it was not enough to find the killer.

In 1932, to memorialize Louise and Mabel, the Women's Civic League of Brooklyn planted shrubs and a shade tree in the corner of Brookside Park on West Twenty-fifth Street not far from the Cleveland Zoo. Cuyahoga County teachers had a fountain placed at the site, and Cleveland teachers provided a bench. The Alpha Kappa Sigma chapter of Baldwin Wallace College donated another bench in memory of Mabel. The Gleaners Class of Brooklyn Memorial Methodist Church placed a bench at the site in memory of Louise.

The memorial reads:

In memory of
Mabel Foote
And
Louise Wolf
Erected by
Women's Civic League
Of Brooklyn
Dec. 1, 1932

3

WAS IT MURDER
OR SUICIDE?

Stow dairy farmer Charles Chandler did not sleep well on Wednesday night, May 29, 1929. Maybe it was because of the oppressive heat. Maybe it was because he was upset with his wife, Jane, for having an affair with their former boarder. Or maybe it was because he feared for his life.

He spent that sleepless night in his son Clyde's room. The ten-year-old boy said his father arose on Thursday morning, Decoration Day, before sunrise and went out of the house. He came back five minutes later and sat on the edge of the bed for a time. Clyde said his father, clad in no more than his underwear and corduroy pants, walked into another room and spoke with another family member, then left the house again. He was not even wearing shoes. Clyde assumed his father was going out to milk the cows and tend to the regular morning farm chores. Little did he know that he would never see his father alive again.

Married since 1911, Charles and Jane lived with their five children in a small, white farmhouse on Darrow Road. It was the house where she was raised, and the land belonged to her father, Alfred Moon. Her great-grandmother was Fanny Bird Cochran, the sister of James Bird, who was killed after the Battle of Lake Erie. Jane was thirty-eight years old and seven months pregnant with their sixth child. Besides Clyde, their other children were sixteen-year-old Helen, twelve-year-old George, nine-year-old Walter and four-year-old Edward.

Jane awoke that morning when her husband's alarm clock sounded. She went to turn it off and found he was gone, but his work clothes were

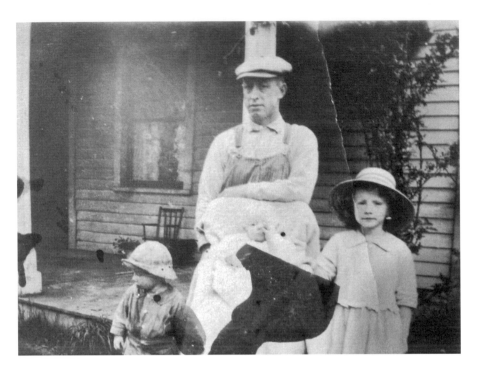

Charles W. Chandler with children (left to right) George, Clyde and Helen. *Courtesy of James Chandler.*

lying on the floor beside the bed. She and the children called out for him but got no answer. They searched the barn and sheds, but he was nowhere to be found. The farm truck was still in one of the outbuildings, so he had not driven away. It was peculiar that none of the early morning chores had been done. He always milked the cows first thing, but they were still fresh.

Thinking perhaps their father had sought relief from the sweltering heat in the cool waters of nearby Meadowbrook, the boys followed the stream for several miles and found no sign of him. The family also contacted Charles's mother in Dexter City, but she had not heard from her son.

Jane waited a full day before notifying authorities. She later would claim she waited because she thought he would return.

Twenty-five sheriff's deputies, headed up by Deputy Bert Karg, descended on the property and combed the surrounding woods and fields. They found no trace of the man. Karg was baffled by the disappearance and became particularly suspicious when he found bloodstains on the porch and kitchen floors of the house. "Both the porch and kitchen had been scrubbed," he

told a reporter for the *Akron Press*. "Mrs. Chandler explained the stains away by saying one of the boys had had a nosebleed."

The family's theory that Charles left home voluntarily did not add up for Karg. For one thing, the family said Charles had forty dollars when he disappeared, and Karg found forty-two dollars in the pocket of pants hanging in the bedroom. The family also said Charles had but two pairs of shoes. One pair was found in the house; the other was found in the woodshed. The deputy wondered why the man would leave home with no money in his pocket and no shoes on his feet.

Karg was becoming more and more certain that Charles had met with foul play, and perhaps his body was buried somewhere in the woods or hidden in the underbrush. Five days after the hunt turned up nothing, Karg decided he needed more searchers and enlisted the Boy Scouts from Tallmadge and Stow to help beat the bushes in a three- to five-mile radius. A swamp near Call's Pond close to the farm was searched at that point, and Karg was thinking of dragging the pond itself.

When Karg pressed Jane further, she said he may have suffered a memory lapse due to the heat. "He never appeared to suffer from the heat before, but he complained about it a great deal Wednesday," she said. In fact, he retired Wednesday night after complaining of the weather. Other than that, the evening was uneventful, and no one heard any kind of disturbance during the night or in the morning.

Jane told the deputy that there had been no quarrels. "He never said a word about leaving. He had no enemies as far as we know and we have lived here on this farm for fifteen years."

There did not seem to be much in Charles's background to provide clues. He was born in West Virginia, the third of six children. His father, Samuel J., died when Charles was only eleven, and his mother, Mary Mariah, moved Charles and his siblings to

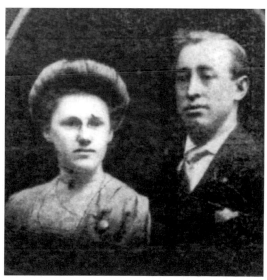

Jane and Charles Chandler. *Courtesy of James Chandler and Debi Heppe.*

Noble County, Ohio. Charles and Jane married when she was nineteen and he was twenty-six.

The night before Charles disappeared, he had gone about his regular routine. His family told investigators that he did his evening chores and rubbed down an ailing horse, then went to bed around 9:00 p.m.

At first, the very pregnant Jane appeared to not handle her husband's disappearance well. She expressed the fear that Charles may have met with an accident and been seriously injured or killed. After a few days, she put on a flimsy, pink nightgown, took to her bed, let all the housework go and talked to no one.

Karg found out from neighbors that despite Jane's assertion that there had been no quarrels, there were frequent domestic disturbances. One woman was overheard saying if she told what she knew about Chandler's death, someone would go to the penitentiary.

Deputies talked with neighbors who told a story different than Jane's. They said Charles had left home twice before, and he was gone one of those times for three months. One close neighbor said he saw Charles board a milk truck that came by his home that morning. The milk company's officials spoke with the truck driver and got a denial of the story.

Some of the neighbors seemed to think Charles was worried, even frightened. One of his friends told authorities that Charles had once said to him, "I'm afraid they'll get me. They may bump me off." To his closest friend, he said he "could not see it through." The friend took that remark as reference to the trouble with his wife and the boarder.

Most of the disturbances centered on C.D. Hougland, a thirty-year-old Copley man who had been a boarder at the Chandler house. When questioned, Hougland admitted to having an affair with Jane Chandler during the seven months he lived in the Chandler home. The affair ended when Charles ordered him to move out of the house. Hougland told authorities Jane had sent him three letters after he moved out, but he returned them unopened.

This information, along with the bloodstains, was enough for Karg to hold Hougland at the county jail. Judge Gordon Davis set his bond at $2,000.

While assistant prosecutors Michael Fannelly and George R. Hargreaves leaned toward Charles either leaving home voluntarily or committing suicide, they wanted the investigation to go forward.

Neighbors and friends who knew Charles said he was not the type to do away with himself. Deputy Karg agreed. He concentrated his efforts on Hougland and tried to get a straight story out of him. "He told me he

went coon hunting the night Chandler disappeared," Karg told *Akron Press* reporters. Hougland said he had been out most of the night in his small coupe. "He has been unable to produce anyone to verify his story," Karg said and pointed out that Hougland had lived in the Chandler house for several months, so it was obvious he was familiar with Charles's habit of going out to the yard at the same time every morning.

Helen, the oldest child, added a bit of information. She said many mornings the dogs would start barking around 3:00 a.m. One time, she looked out her bedroom window and saw two men running from the barn toward the road.

In Hougland's haste to move out on January 5, he left a suit of his clothing behind. Family members said the clothing disappeared two weeks before their father came up missing. This lent credence to the theory that Charles planned to drop out of sight and that he may have changed into the other man's clothing. If this were true, it seems as though the corduroy trousers would have shown up somewhere during the search, and he would have taken his money and worn shoes.

Finally, late in the afternoon on Friday, June 7, nine days after Charles had gone missing, the authorities were summoned to Howard M. Call's farm on Fishcreek Road. Twelve-year-old Chester Graves and eight-year-old Richard Call had been swimming in the small artificial lake on Call's property and had seen Charles's body floating in the water.

The body was two hundred feet out from the shore. Karg had no boat, so he had to swim out to get it. Dragging it back to shore was arduous because it was weighted down with three large paving bricks, each weighing at least ten pounds. They had been placed inside a burlap feed sack, then cinched to Charles's body with two knots in a cotton rope. Karg examined the position of the rope and decided there was no way Charles could have tied the two knots himself.

One newspaper account said that Helen Chandler was there to see her father pulled out from the water and that she and Howard Call identified him. Later in life, when family members asked her about Charles's death, she said she could not remember much. They thought she just did not want to talk about it.

Charles's body bore no immediate signs of violence, and his hands and feet were free, leading both Karg and Prosecutor Hargreaves to believe he was either dead or unconscious when he was put in the water.

How the body got out into the middle of the lake in twelve-foot-deep water was a mystery. Call's lake had been man-made by damming up a

stream. There was no current in the water, so Karg did not think the body could have drifted out to the center. Because there were no boats anywhere on the lake, the deputy knew no one could have rowed out to the middle of the water to dump the body. It would have been nearly impossible to carry a weighted body—or the three ten-pound bricks alone—three-quarters of a mile over the fields from Chandler's farm, then slog through a swampy area at one end of the lake. The distance was three miles by roadway down a lane that ran off Fishcreek Road, so authorities figured an automobile had been used to transport Charles's five-foot, eight-inch, 170-pound body.

The bricks, feed sack and rope came from Chandler's farm, so it looked like Charles had been killed on his own property the morning he disappeared.

Karg was puzzled by the fact that Charles's body was fully clothed and had on a pair of worn-out shoes, one of which was tied up with cord instead of a shoelace. The deputy remembered that Charles's son Clyde had said his father left the house wearing only trousers and no shoes. Karg, himself, had found Charles's only two pairs of shoes, one in the house and one in the woodshed.

Summit County coroner Milton B. Crafts ordered an autopsy. There was an absence of water in Charles's lungs, a first indication that the man had been dead when he was placed in the water. Crafts was cautious, however, and told the newspapers that it was possible tissue gases could have pushed water out of the dead man's lungs. (Modern-day medical examiners recognize that a laryngeal spasm can suddenly seize the vocal chords, blocking the flow of air into the lungs. This is known as dry-drowning.)

To determine if foul play was the case of death, Dr. Frederick Potter sent lung and kidney samples to Akron Peoples Hospital for testing. The test would also show if he had been poisoned before he was put in the lake.

Hargreaves was now thinking that Karg was right: Charles Chandler had been murdered. "All of these things indicate that Chandler was the victim of some sort of murder plot," he said.

Hougland had already been released but was rearrested at his home near Copley when Charles's body was found. Hargreaves questioned him all that Friday night and into Saturday morning. There were discrepancies in his story. At first, he said he was fishing alone the night before Charles disappeared. Later, he told the prosecutor he was in bed asleep that night.

Meanwhile, a story circulated that Charles had $200 on him when he disappeared and that Hougland most likely knew about the money. Assistant Prosecutor Fannelly said to an *Akron Beacon Journal* reporter, "We are told that following Chandler's death: the suspect lost more than $100 betting at a race track." Hougland also allegedly spent $80 on a spree in Akron. There

was little evidence to confirm this, and the Chandler family said Charles had only $40.

"Everyone who ever had domestic dealings with the Chandlers will be questioned," Hargreaves told the reporters.

Karg started the questioning with Hougland's father, who said his son had been coon hunting on the night in question.

A neighbor told deputies that Hougland had threatened to kill Charles during an argument the two had over the illicit love affair. Charles even sent his brother, James, who lived in Kent, a letter expressing fear. James handed that letter over to authorities.

Two more men were arrested in the next few days. One was a fifty-one-year-old neighbor who often worked on the farm. He said he had fallen asleep while fishing and did not get home until just before the Chandlers knocked on his door asking for help. The other was a twenty-one-year-old friend of the Chandlers' sixteen-year-old daughter, Helen. He could not account for his whereabouts at the time of Charles's disappearance. They were held along with Hougland and questioned aggressively.

One of these men had bragged that he knew of a murder plot. There was evidence that he had burned a document after Charles's death. Curiously enough, Jane would later admit that after her husband's disappearance, she destroyed a paper that was held behind a picture. There was no mention of what that document was. Hargreaves and Karg drew conflicting stories from all the suspects and had to admit they were stumped. None of the three admitted any part in Charles's death.

The preliminary pathology came back from Peoples Hospital, revealing the presence of either mercury or arsenic in the tissues. Coroner Crafts was now comfortable saying Charles was not a victim of drowning but was most likely dead when put in the lake. The coroner asked for more tests on the kidney sample because a bottle containing mercury pills was found at the Chandler home. Hougland freely admitted the bottle was his. He said he used it as a medicine and had forgotten it when he left the Chandler household. At the time, mercury was used to treat syphilis, typhoid fever and parasites.

Hargreaves and Karg concentrated on Jane Chandler. Up until Charles's disappearance, she had been active and had performed her normal household duties with no problem. Soon after Charles vanished, she took to her bed and claimed to be too sick to answer questions. It was noted that she took her husband's death with relative calm.

Before questioning her, the prosecutor wanted her examined by a doctor to see if she was fit for an interrogation. Dr. Sidney B. Conger examined her

at her home and said she was in good health. She was taken into custody and, in the presence of a female probation officer, Greta Footman, grilled for twenty-four hours. Part of that time, she was quizzed in front of two of the suspects.

During questioning, she retraced her steps on the morning of Charles's disappearance, starting with turning the alarm clock off at five o'clock. After she and the children searched the property, she sent one of the boys across the street to a neighbor's house because he often worked on the farm. The neighbor was one of three men in police custody.

When asked if her husband had enemies, she said, "He liked everyone and never said anything unkind about anyone."

She continued to claim that they never argued. "I used to say that it was unusual for two people to live together for fifteen years and be so peaceful. He was easy to get along with."

Their only problem was losing their cows in the fall in the tuberculosis test, but Jane said they were "getting everything back in shape."

Jane denied the rumor that she told her children their father would never come home.

The murder case fell apart when the second pathology test came back. Dr. Potter found no conclusive evidence of foul play. This time, he could find no signs of poison in Charles's system. Although the suspects had to be released, Hargreaves declared the murder probe would not be dropped.

In August, the family hired two private detectives, and county authorities cooperated. This time, they concentrated their investigation on what they believed was the theft of $200 Charles had when he vanished. But the inquiry came to a standstill. In the end, Crafts, Potter, Hargreaves and Karg felt there was motive for murder, but there was also motive for suicide. Charles's brothers and sister never accepted the suicide theory.

One month after her husband died, Jane Chandler gave birth to a baby boy and named him Harold. He died in his crib at only three months. He was buried next to his father. Jane married Hubert Davis, moved to Kent and had two more children. She suffered from heart problems and pneumonia and died on December 23, 1933, at the age of forty-two. She is buried next to Charles and baby Harold in Maple Lawn Cemetery.

THE DISAPPEARANCE OF
MELVIN HORST

On Thursday, December 27, 1928, a Christmas tree decked out with glittering tinsel and multicolored glass ornaments occupied a corner of the living room in a humble brown house on McGill and Paradise Streets in Orrville. The Christmas presents had been opened and were already scattered about the house—all except for one little toy truck still parked under the tree. It had been a present for Raymond and Zorah's four-year-old son. It was a toy that the little blue-eyed boy would never play with again.

The last time family or friends ever laid eyes on Melvin Charles Horst was late on that Thursday afternoon. The lad had bundled up in a homemade dark brown overcoat and a brown hand-knitted cap with earflaps to go out and play with two other boys in the school yard at the south end of the village. The other children were a little older than Melvin, who, at forty-five pounds, was large for his age.

It was dusk, about 5:15 p.m., when Melvin's playmates were called in to supper. Melvin was left to walk by himself the block and a half home through a short alley. When he was not home by 5:30 p.m., Zorah began to worry. She said he regularly played with his friends at the school ground, but he always came home for dinner. He never stayed away.

Raymond Horst and the neighbors searched for two hours before calling his brother, Orrville city marshal Roy E. Horst. Once the marshal became involved, he called up his night marshal and organized search parties, including the local Boy Scouts troop. He alerted police departments and

hospitals in the surrounding communities. An Akron radio station, WADC, broadcast Melvin's description.

Orrville was a prosperous railroad and manufacturing town of 4,600 residents at the time, and nothing like this had ever happened. Approximately 300 men, women and children turned out to help comb the neighborhoods but with no luck. The search went on throughout the cold, winter night and well into the next day.

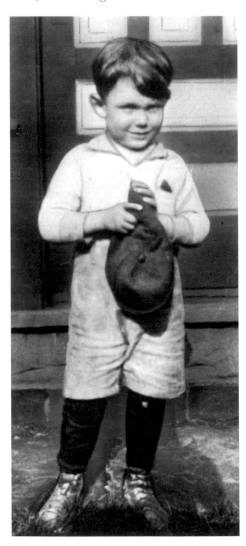

Four-year-old Melvin Horst. *Courtesy of the Akron Beacon Journal.*

Marshal Horst's first thought was that the self-reliant little Melvin could have wandered away and gotten lost, perhaps met with an accident. When daylight came, the search party investigated every abandoned structure, barn, outbuilding and garage and pulled up every cistern and well cover. They checked every manhole and examined every sewer pipe in Orrville. The fire department found a small hole in the ice in Dye's pond at the edge of town. There were no tracks around it, but the firemen dragged a portion of it anyway. Fireman later dragged the entire pond. Searchers beat through snowy thickets and rooted through every ravine. Every inch of a 175-acre field of railroad ties at a creosoting plant just east of town was scoured. But there was no trace of the boy.

An estimated seven hundred residents took part in the forty-hour search. It was one of the most extensive manhunts in all of Wayne County history. Not so much as a shoelace was found.

Raymond and Zorah were afraid someone had kidnapped

Melvin. Zorah said he had no fear of strangers and would talk with anyone. At first, the police rejected the kidnapping idea because the Horsts had no money to pay a ransom demand. Raymond was a roofer at Nuroy Roofing. The family lived a few blocks from the center of town in a rented, story-and-a-half house with their other two children, Ralph, who was eight, and Elzia Dora, who was one. They had no enemies.

Zorah made a tearful plea over the radio for the return of her little boy. "Bring back my son…Our home is marked with sadness at this season of the year," she cried. "Please, oh, please, bring my son back to his mother."

Mayor A.U. Weygandt told *Canton Repository* reporter C.W. Howard, "We hope that if the boy has been kidnapped, no one in Orrville is implicated." If any resident was involved, he said, he hoped that person would be found out and appropriate action would be taken.

Melvin always took that shortcut on his way home from the school yard. It was a one-thousand-foot alley that passed garages and other outbuildings. It could be quite dark after the sun went down. Toward the end was an unpaved, narrow path through weeds grown up around tire tracks. Somewhere in this section, Melvin had vanished. While a witness claimed to have seen him start down the alleyway, no one saw him emerge from it.

As the hours ticked away with no trace of the little brown-haired boy, police started to look at sex offenders, known as "perverts" at that time. Marshal Horst had knowledge of three such people in Orrville who might be capable of abducting a child. All three of these men had alibis, and police did a thorough search of their homes. Nothing suspicious came out of those searches.

A citizen's committee raised $1,000 for a reward. The Rotary and Kiwanis added $100. A short time later, an Orrville businessman donated $500. Other businesses gave another $1,400.

Marshal Horst's resources were slim. He had led the hunt for his nephew with only a handful of patrolmen, and he had gone without sleep for days. He finally collapsed with a severe case of influenza.

Surprisingly, Wayne County sheriff Albert Jacot declined any help. He was told of the disappearance at the onset of the search, but he wanted no part of what might become a long-standing case because he wanted to retire from office.

At this point, it probably became apparent to Mayor Weygandt and Prosecutor Walter J. Mougey that Marshal Horst and his patrolmen could not handle the investigation by themselves.

Mougey called in famed detective Ora Slater of Cincinnati to help. A well-known detective from Millersburg, John "Peggy" Stevens was hired by a citizens group. Both answered to Prosecutor Mougey.

Four days into the investigation, detectives found an eight-year-old boy who had a story to tell. He was a fair-skinned, bright lad named Junior Hanna who was related to the Arnold family, a name synonymous with trouble in Orrville. Elias, sometimes known as Nul, was Junior's uncle; William, Arthur and Dora were his cousins; and Bascom McHenry was married to Dora. Coincidentally, their house backed up to the alleyway where Melvin was last seen.

Junior claimed to be playing with Melvin until the boys were called to supper. According to Junior, sometime previously, one of the Arnolds told him he was "looking for Melvin Horst to give him something." During another interview with one of the detectives, Junior said he saw Melvin go into the Arnold house and a few minutes later come out with Bascom McHenry. They got in a car and drove off. Junior changed his story often, always saying that he "wanted to do the right thing" and that an angel appeared to him and "urged him to tell the truth."

Junior's father said his son could not possibly have been with Melvin right before he disappeared because he was home eating his supper. He recanted that statement later, giving no reason.

Prosecutor Mougey got permission from the common pleas court judge to hold Junior on a substantial bond in the Children's Detention Home as a material witness. Material witnesses were sometimes held in seclusion, and bond was usually reserved for someone who was a flight risk.

Junior's revelations caused investigators to focus their suspicions entirely on the Arnold family because of the past run-ins with Marshal Roy Horst, Melvin's uncle. White-haired, sixty-year-old Elias Arnold was a bricklayer by legal trade. By illegal trade, he was a bootlegger who had been arrested by Roy Horst multiple times. His son, thirty-year-old William, served time in the Ohio State Penitentiary for complicity in a robbery. He lived in Akron. Another son, seventeen-year-old Arthur, had a record of misdemeanors. Described as looking like a sheik in a *Plain Dealer* article, he spent much of his time hanging around the pool hall. Elias Arnold's daughter, twenty-two-year-old Dorothy McHenry, had no record, but her husband Bascom had been in trouble for disturbing the peace.

Acting on Junior Hanna's information, the detectives started rounding up the Arnolds and McHenrys at three o'clock in the morning on January 2. They were charged with child stealing rather than kidnapping and held on $10,000 each. The penalties for kidnapping and child stealing were different. Under Ohio State law, kidnapping carried a sentence of one to twenty years and involved the abducted victim being taken out of state. Child stealing

involved anyone who lured, enticed or stole a child under the age of twelve and carried a lighter sentence.

The Arnolds were held in separate jail cells. They were also questioned separately in hopes that one of the family members might break down and admit to snatching little Melvin. Under interrogation, Elias Arnold answered only the questions he wanted to and smiled to evade others. He did confess that he "had it in" for Roy Horst and had made threats against him in the past.

Prosecutor Mougey acknowledged the case against the Arnolds and McHenrys was completely circumstantial, even flimsy, but he figured it was enough to take before a grand jury. Mougey claimed Arnold's motive was revenge against Marshal Horst because Horst had arrested members of the Arnold family several times. Mougey further tried to convince the grand jury that Elias thought Melvin was the marshal's son.

William Arnold and the McHenrys' alibi of eating supper at an aunt's house, then going to a basketball game in Fredericksburg held up, so Mougey had to drop his case against them. But Elias and Arthur could only vouch for each other.

Detective John Stevens looked for clues in the alleyway where Melvin was last seen and came upon a niche where someone could have hidden in wait. The spot was between the Arnolds' house and the alley's entrance. Stevens also claimed to have found a frozen orange with one bite gone out of it and a pint of whiskey on the ground nearby.

One of Detective Ora Slater's first acts was to sift through the ashes in the Arnolds' furnace. He did not disclose what led him to be suspicious of the furnace contents until those ashes revealed some good-sized bone fragments, as well as something that looked like a button. However, when the fragments were analyzed by local physicians, they were deemed to be chicken, beef, rabbit and pork bones. What Slater thought might be a button turned out to be a piece of metal, and Zorah told him that her son's buttons were not metal.

The Horsts left lights burning every night in belief that little Melvin would come home. "We know that Melvin will come back, all right," Zorah told a staff reporter for the *Plain Dealer*, "and if it's in the night time, we want the lights to be lit so Sonny won't be afraid. But anytime, night or day, the door will be unlocked so that he can walk in."

Christmas was well past, but the gaily decorated tree still stood in the Horsts' house. Melvin's toy car had not moved. Ralph and Elzia Dora watched out the window everyday for their brother, too young to understand why he did not come home.

Mougey went out of office on January 7, and Marion Graven became the new prosecutor. Graven appointed Mougey as the special prosecutor for the case because he was so familiar with its details.

Elias and Arthur Arnold's trial took place in March 1929. They were defended by A.D. Metz, a diminutive old attorney with a combative style. In his opening statement, he declared his clients had been framed by Detective John Stevens so he could collect the reward money.

"The defendants in this case have absolutely no knowledge of the disappearance of the boy," he hammered. "They do not know who took him or how it was done." He insisted the Arnolds did not even know Melvin Horst. "Even so," he said, "they joined in the search for the child."

Metz attacked the prosecution for keeping Junior Hanna in seclusion so he could not interview the boy.

White-haired Elias Arnold sat at the defense table with his hands clasped in front of him, his thumbs slowly circling each other while his deep-set eyes watched every move. His white moustache fringed a frowning mouth.

Young Arthur, dressed in a three-piece suit, slumped quietly down in his chair throughout the proceedings. He showed little emotion but looked perplexed when Junior testified.

The state's case was built primarily on Junior Hanna's testimony. Mougey spent the morning of the trial with witnesses building up to Junior's turn on the stand. A couple of young boys testified that they saw Junior and Melvin together right before the latter went missing. Junior's mother testified that she and her son went to the store, but she lost track of her son after 5:15 p.m. that day.

Eight-year-old Junior took the stand and told the court he saw Arthur offer Melvin an orange. Melvin took a bite from it but dropped it when Arthur scooped him up and carried him into the house, he said.

Metz surprised the prosecution with the testimony of Ora C. Watts, a night patrolman in Orrville. Watts had searched Arnold's backyard two days before the orange was discovered. He was looking for buttons or trinkets that could have belonged to Melvin. He also kept an eye out for blood. "The search I made was so thorough that an orange could not have been there without my seeing it, and I saw none," he testified. Watts also told the court that he made a careful check of the homes in that area and determined that all neighborhood children, except Melvin, were home by 5:30 p.m.

The Arnolds both took the stand. Elias's voice was low and throaty when he admitted to Mougey that he was a bootlegger. He also admitted to having a grudge against Marshal Roy Horst for arresting him for liquor violations

but emphatically proclaimed his innocence of child stealing. "If I wanted to get even with Marshal Horst, I'd take it out of *his* skin."

Young Arthur was on the stand for more than an hour while he described his actions on the day Melvin disappeared. His black hair neatly combed, he turned to face the prosecutor and flatly denied seeing Melvin that day. During his testimony, he told jurors that he had never finished school, and since this had happened, his only friend had "deserted me, now."

When asked what he did the day of the alleged kidnapping, he said he had been downtown and after that "I was playing the player piano." He said his father was reading.

In his closing argument, Metz seized on the fact that Junior Hanna had not come forward with his story for four days. "It has been an entirely reckless manner in which the state has come into court to indict the Arnolds," the old attorney railed. "They are basing the charge against them on the testimony of an eight-year-old child on a story born in a plastic imaginative mind." He raised the question of why the state kept Junior in the children's home after he came forward.

In spite of Metz's fiery defense and closing argument, the seven-man and five-woman jury found the Arnolds guilty after deliberating for seven hours and twenty-two minutes. The two men faced from one to twenty years in prison.

They were taken back to their cells in Wayne County Jail to await sentencing. "I'm not worrying much, though," Elias said. "I'll fight the case to the very limit."

"We're innocent, and we'll prove it." Arthur chain smoked as he talked. He said Junior Hanna's story was not logical. "I could pick holes in it myself."

The Arnolds asked to speak to Detective Ora Slater. "For God's sake, find that boy," they said as they shook his hand.

Elias Arnold was sentenced to the Ohio State Penitentiary for twenty years. His son Arthur was sentenced to an indeterminate period of time at the Mansfield Reformatory.

While the Arnolds' attorneys continued to fight for a new trial, the hunt for Melvin continued. Thousands of circulars describing Melvin were distributed to police departments all over the state.

Rumors and tips were brought to the authority's attention. One tipster said a boy fitting Melvin's description had been seen with an older woman coming from a train in Columbus. Another informant claimed that Melvin had been hit by a Columbus bootlegger's car and his body was either thrown in the Scioto River or buried somewhere. None of this could be substantiated.

Some of the neighbors told Stevens they had seen a green car cruising the area. This time, someone claimed to have seen two men, a woman and a child in the car, and the child was in distress. The car was never found. Detectives were called to Gnadenhutten to investigate a headless body the size of a child wedged in a tree trunk. It turned out to be a rag doll. The bootlegger angle surfaced again and again. One story described the car as a green Hudson with wire wheels. The owner of that car was a rumrunner, but he had an airtight alibi.

Although the common pleas court judge denied the Arnolds a new trial, the Ninth District Court of Appeals reversed the common pleas court decision on the weight of the evidence presented by new defense attorneys Nathan E. Cook and William F. Marsteller of Cleveland. The court found the admission of Junior Hanna's testimony to be in error. Two of the three appellate judges favored discharging the Arnolds all together, but exoneration required a unanimous consent from the court. Wayne County prosecutors Mougey and Graven tried to get the state Supreme Court to deny a new trial, but the high court upheld the district court's finding.

The new trial was set for December 1929. Elias Arnold was freed on $10,000 bond. Arthur Arnold was kept in the Mansfield Reformatory.

Cook and Marsteller of Cleveland were certain the evidence had been trumped up and took the fight forward from that position. They scored points in the new trial when they introduced two differing written statements by Junior Hanna.

The state tried to keep the statements out of the proceedings and almost succeeded when the judge declared them to be personal property of the prosecution. Marsteller countered by calling Prosecutor Mougey to the stand and asked for Junior's statements. This time, the judge ordered the statements to be produced. The defense then set out to prove that Junior had made five statements altogether and no two were alike.

Although Junior had testified in the first trial that he saw Arthur take Melvin into the Arnolds' house, in the two written statements, he made no such assertion. Instead, he wrote that he left for home before Melvin went into the alleyway. In another statement, he said he had seen Arthur and Bascom McHenry in the window of the Arnold house.

Marsteller wanted to know: When was Junior telling the truth? When he was on the witness stand? Or when he made the written statements days after the disappearance? One of Junior's statements said Bascom McHenry was Arthur's accomplice in stealing Melvin. In another statement, Junior said Elias was Arthur's accomplice. The defense attorney asked why he

waited four days after Melvin went missing to tell his story. "Nobody asked me," Junior said. Previously he had said he was afraid to tell.

Marsteller extracted from Junior that one of the statements was written when Stevens and Mougey visited him at the Children's Detention Home, where he had been held as a material witness. Before that, Junior had written that Bascom McHenry took Melvin in the house instead of Elias. Marsteller contended that Stevens and Mougey had already found out through the investigation that McHenry had an alibi, so they wanted Junior to name Elias as Arthur's accomplice. Marsteller also accused Stevens of being after the reward money.

In the first trial, Junior testified that he met up with two of his friends at 5:15 p.m. just as he was leaving Melvin Horst. Marsteller put a railroad freight agent on the stand to discredit that. The agent had seen the two named boys at the depot putting out a fire. The agent looked at the railroad clock, which said 5:12 p.m. The depot was blocks away from where Junior claimed to have met his friends.

The defense lawyers produced witnesses who saw the Arnolds at different times during the day of Melvin's disappearance. Mougey was quick to point out the time gap between 4:50 p.m. and 5:30 p.m.—a gap, he argued, that was time enough for the defendants to grab Melvin.

Both Arnolds took the stand again and carefully went through their day. When it came right down to it, they were each other's alibis during that short period of time. Under cross-examination, the prosecutor grilled Elias about his criminal record, trying to prove a motive for vengeance against Roy Horst. Elias admitted having a record but denied seeking revenge.

Mougey took a different tack this time and attempted to establish a motive for abducting Melvin. He questioned Marshal Roy Horst for several hours, trying to bring out how many times he had arrested one of the Arnolds. The judge allowed Mougey to count up the arrests but not to tell what the arrests were for.

Prosecutor Mougey stated to the jury that Melvin's disappearance would have been the "perfect crime" except that Arthur employed Junior Hanna "as his cat's paw" to entice Melvin. He told the twelve jurors to find the Arnolds guilty so that "children will be safe in their homes."

According to a *Plain Dealer* article, Mougey brought his final argument to a dramatic close by saying, "It is a crime against motherhood to go down through the valley of death to bring forth a child to be used in a revenge plot."

During Marsteller's final argument, he told the jury that without Junior Hanna's testimony, there was not one iota of evidence that the Arnolds had

anything to do with Melvin Horst's disappearance. "He [Junior Hanna] had made himself the hero of one of the strangest cases ever tried in Ohio," Harriet Parsons of the *Plain Dealer* reported the defense attorney saying.

For the second time in nine months, Elias and Arthur Arnold's futures were in the hands of a Wayne County jury. It took the eight men and five women less than six hours to come back with a verdict of not guilty.

After the trial, a frail-looking Zorah Horst went home to be with her other children and her husband. Asked about the verdict, she said she could not give up hope. "The jury's verdict knocked all the breath out of me. I don't know what to think."

Mail sacks full of letters kept coming into the prosecutor's office offering sightings and neighborhood suspicions and clues. There was a tangle of rumors, counter rumors, hearsay and tips within the pile. One of those letters was mailed to William G. Heebah, editor of the *Courier Crescent*. The writer said he and Melvin and would deliver "the boy alive, to the arms of his mother," in exchange for immunity and "$100 as expense money." The letter went on to read, "Providing we are not arrested or prosecuted, because

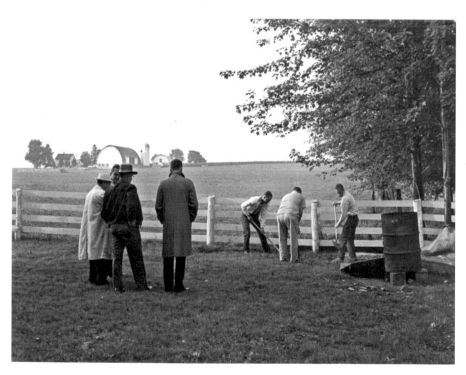

Digging for the body of Melvin Horst beside a fence seen in a vision by an Akron woman. *Courtesy of the* Akron Beacon Journal.

we know nothing of the disappearance of the boy, only we have him now." It, too, was a cruel hoax.

The same Christmas tree from the year before still stood in the corner of the Horsts' living room, brown needles fallen on the carpet, bare limbs holding up colored balls and silver tinsel. Zorah insisted that the tree and the little truck would stay there until Melvin came home. She said there would be no celebration and no presents until he did. But Melvin never came home to play with that truck that Christmas or any other Christmas.

Wayne County sheriff Glenn Rike looks over bones buried in the East Union Evangelic Lutheran Church yard. *Courtesy of the* Akron Beacon Journal.

Twelve years later, Ohio governor John W. Bricker ordered an investigation into the disappearance, but it came to naught.

In 1962, an elderly woman contacted *Akron Beacon Journal* reporter Ken Nichols and told him she had "persistent visions" of what happened to the Horst boy. She claimed to see three men burying the boy's blanket-wrapped body at night somewhere in the yard of a small white church by a fence corner and a nearby field. The woman also heard voices, telling her the church yard was in Wayne County between Orville and Wooster. The woman told Nichols that the men did not know the boy. They had hit him with their car at night. It was an accident, she said. They had no insurance, and they did not know what else to do.

Nichols's interest was piqued. When he was not working, he drove through the Wayne County countryside looking for a spot that matched her description. He finally found the East Union Evangelical Lutheran Church on Route 30 heading toward Wooster. The church was small and white, just like she described. There was a fence corner and a field close by.

The church council gave permission to dig as long as the Wayne County sheriff Glenn Rike and the Pastor Robert Niemiller were there. A small leg bone, spine and jaw bone turned up under the second post, but nothing else. Rike believed the bones belonged to a dog or cat. Just to be sure, he sent them to Wayne County coroner L.A. Adair, who confirmed that they belonged to a small animal. They were not human. Still, there were no answers.

What happened to the little blue-eyed boy named Melvin Horst? Someone knew, but that someone is most likely already dead.

DEADLY DEALS

During the Roaring Twenties, Republican councilman William E. Potter was one of the most flamboyant and powerful politicians ever to hit Cleveland City Hall. Talkative, witty and sometimes charming, his fiery red hair and round glasses were his trademark. He served for ten years, earning the nickname "Rarin' Bill" for his ambition and aggressiveness.

"You always knew where Potter stood," city council clerk Fred Thomas said. "If he was against you, he didn't keep that a secret." It was well known that if you wanted something done in Cleveland, you went to Bill. His story is that of scandal, political greed, legal entanglements and, finally, murder in 1931.

Some of his scrappiness and talent for deal-making was attributed to his roots on the streets of Chicago as a "newsy," according to some contemporary newspaper accounts. After all, it made a better story than what the 1930 census revealed—that he was actually born in Ohio in 1885 to parents who came from Pennsylvania. There's no documentation that he ever made any effort to change that perception. Instead, he often told a tale about a wealthy old man who picked him off the streets and took him home. When the old man's wife got a look at the ragged youth, she screamed so loud that the young Bill ran from the house.

In later years, *Plain Dealer* reporter Ralph J. Donaldson wrote that Potter was born on Oregon Street in Cleveland, one of nine children. His parents died when he was quite young, and he and his siblings were separated.

Rarin' Bill got his first taste of politics during his teens when he attempted to become a unionized bricklayer. At the time, he was an

apprentice in Rochester, Pennsylvania, helping to rebuild a burned-out glass factory where he had been working. The union turned down young Bill because of its rule that did not allow apprentices to join the union unless their fathers were bricklayers. Not one to take no for an answer, Potter lobbied all the traveling bricklayers to go to the union meeting and vote to let him in. It worked.

As a young man, Rarin' Bill moved to the Collinwood district in Cleveland. He made his living as a bricklayer and was voted an officer in the bricklayers' union. Well liked by his neighbors, he caught the attention of Republican mayor Herman C. Baehr. Around 1910–11,

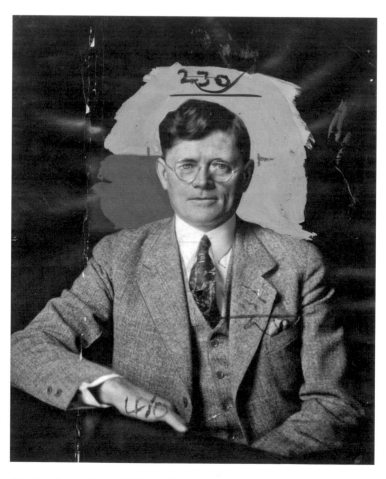

Cleveland councilman William "Rarin' Bill" Potter. *Courtesy of the Cleveland Public Library.*

Baehr appointed him chief inspector of masonry in the city's building department, a job he held for about eight years.

After two unsuccessful bids for minor political offices, Potter ran a winning campaign in 1919 for the city council seat from the Collinwood Fourth District, Twenty-sixth Ward. As councilman, he quickly became the darling of Maurice Maschke's Republican Party for helping to turn three wards in his district red.

During Rarin' Bill's tenure on the council, he served on the public utilities, police and fire standing committees, but most importantly, he held the position of chairman on both the building code committee and the board of appeals on building code regulations. At the same time, he was personally involved in real estate and was the president of Union Builder Supply & Brick Company.

Rarin' Bill's dual roles did not sit well with the Citizens' League of Cleveland and made enemies of his business competitors. In late February 1925, the league cried foul in a letter to city council. Signed by its director, Mayo Fesler, the letter demanded Potter's resignation from any committee that oversaw construction. It claimed it was a conflict of interest for Potter to have authority over contractors who bought their building supplies from his company, then turned around and appeared before him to ask for building and zoning permits or plan modifications. While most of the council ignored the letter, the council president challenged the league to show evidence to back up its accusations or apologize to Potter.

The league was not about to apologize and told the council in its second letter to find its own evidence. The league offered to employ legal council to facilitate an investigation and to subpoena a list of witnesses.

Councilman John D. Marshall introduced a resolution to address Potter's role as the chairman of both the building codes committee and the board of appeals in relationship to his presidency of the Union Builder Supply & Brick Company.

By this time, Rarin' Bill's temper was beginning to fester. "It's just a lot of politics," he cried. He called Mayo Fesler "a $10,000 a year snooper" and accused his largest business competitors of ganging together with the Citizens' League to attack him.

The judicial committee decided Fesler or other members of the league would have to show reasonable proof that there was a need for an investigation. The league produced evidence for twenty-two cases put before the building code committee or board of appeals where Potter had sold materials to applicants. The judiciary committee exonerated Potter.

The *Plain Dealer* had been reporting on the battle and agreed with the league. In October, it was finally decided to eliminate all council members

from the building board. Finkle offered an ordinance that named the city manager, the law director and the parks director as the new building code board of appeals. That November, the Citizens' League called for the defeat of seven councilmen. William E. Potter was one of them, but he handily won his council seat again.

In November 1926, Rarin' Bill became involved in a land deal with building contractors Abram and Jake Winer. At the time, it looked like the simple sale of a lot on Gray Avenue Northeast and 113th Street, but it would come back to haunt Potter a few months later.

The Winer brothers wanted the lot to build a thirteen-suite apartment building. Potter's mother-in-law, Mrs. Anna S. Hoffman, owned the land, so Potter handled the sale. He and the Winers settled on $2,250 as a fair price, and everyone seemed happy for the time being.

Jake Winer made out a check for $150 as a down payment. He went to apply for a building permit but got the run-around at city hall. He went to Rarin' Bill, who wound up clearing the way for all the stamps and paperwork.

The permit in hand, Winer hired workman to do the excavation for the basement. Three days into the digging, a policeman came by the site and ordered the work to stop and informed them the permit had been revoked. The Winer brothers went to the building commissioner but got no answers. Jake Winer again went to Rarin' Bill and told him that the job was stalled and that he had a construction loan and workmen to pay.

Potter wanted money to help him. "I don't like to work for nothing, you know. I want $200," Rarin' Bill said. The builder had only $100 in cash. Potter took it and said he would take a check for the other $100.

When the two met again a month later, Potter wanted more money. Winer balked at the request, and Potter said, "All right. You'll remember me." Winer did not want trouble, so he relented and gave Potter $300.

The Winers finally learned that the city had had its eye on that piece of land. Rarin' Bill told the Winer brothers to total up all their expenses, including the price for the property. They gave him a figure of $4,000. He drafted an ordinance that provided them with $5,000. The Winers came out of the deal with $800 in cash, but they had lost a building project that could have turned thousands in profit.

The case landed in the hands of Prosecutor Ray T. Miller, who took it before the grand jury. When Winer cried foul, Potter's attorney, James C. Connell, accused him of offering Potter a bribe. Connell pressed further to find out that Miller offered Winer immunity from bribery charges to testify against the councilman.

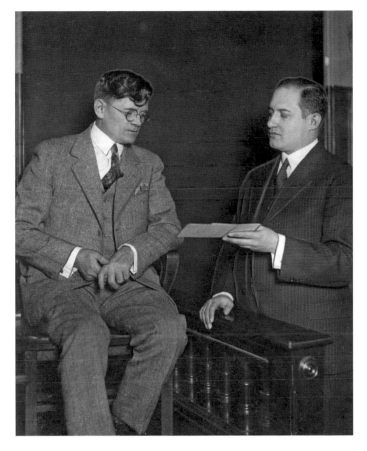

William Potter testified in his own defense under questioning by his attorney, James C. Connell. *Courtesy of the Cleveland Public Library.*

Potter was indicted and tried on graft charges involving the Gray Avenue case but was acquitted.

Another murky real estate deal landed Potter in front of a jury again in 1928. He and Councilman Liston G. Schooley Sr., chairman of the city council finance committee, had their eyes on a lot at the corner of Coit and St. Clair Streets for a community playground. Owned by Michael Froelich, it had been up for sale for some time. Harmon Atwater, Potter's former real estate partner, helped them. Three or four different options were put on the table during the negotiations, and Atwater was able to talk the owners into selling for $50,000. Atwater's intention was to turn around and sell it to the city for $83,250, making a $33,000 profit for himself. He was wrong. It was not going to work that way.

Cleveland councilman Liston G. Schooley pleaded guilty in
the Cleveland land scandal. *Courtesy of the Cleveland Public Library.*

Potter, Schooley and Schooley's son, Liston Jr., hatched a plan to
have Schooley's law and business partners, Charles L. Biggs and George
McEachren, buy the land, then turn around and sell it to the city for $83,250.
Atwater got $4,000 out of the deal. What became of the other $29,000 was
never known.

The Schooleys were both indicted, the father for having a direct interest in
a city contract and the son for aiding and abetting his father.

Potter and city clerk Fred W. Thomas, who was privy to the deal, were
now concerned that they could be indicted, and Schooley was afraid of jail
time. They wanted Atwater to go to Florida, where Froelich was vacationing,

and get him to sign receipts for $83,250. Another councilman was supposed to be at that meeting, but he did not show up. Atwater either never said or never found out who the other councilman was.

He claimed Potter gave him traveling money for the trip to Florida. Thomas said to him, "Goodbye. Good luck. And I hope you bring home the bacon." Atwater made the trip but failed to get Froelich to sign the receipts.

Potter and Thomas then gave him $225 to go to Chicago and stay out of sight until after the Schooleys' trial. On his way from Florida to Chicago, he stopped in Cleveland and was hidden by one of his former associates, Robert Bunowitz.

Harmon G. Atwater was a key witness in the Cleveland City Hall land scandal. *Courtesy of the Cleveland Public Library.*

The Schooleys refused to tell what they knew. Instead, they pleaded guilty. Senior received a five-year sentence. Junior was given a year in prison. Atwater, although missing, was indicted.

From March to September, Atwater lived in rooming houses and hotels in Chicago and received money from Cleveland for living expenses. Miller claimed Bunowitz visited him at least three times. The *Cleveland Press* offered a reward of $2,500 for his return in the beginning of September to face charges of aiding and abetting Schooley. Ten days later, the paper upped the amount to $10,000. Finally, on September 29, 1929, Atwater was apprehended and brought back to Cleveland.

That same month, Republican Collinwood ward leader Frank Blitz yanked party support from Potter. Lack of support had less to do with Potter's legal entanglements than with infighting in the ward, especially between Blitz and Potter. Determined, Rarin' Bill decided to go it alone and run anyway. It was a mistake because he found himself on a losing ticket.

Prosecutor Ray T. Miller cut Atwater a deal to testify against Potter, Taylor and Bunowitz. Atwater admitted to being part of the land deal and fingered Potter and Taylor for plotting to cover up the scheme by having him get Froelich to sign off on the enlarged receipts.

Potter and Bunowitz were both indicted for harboring a fugitive and went on trial. Potter was found innocent on the same evidence that convicted Bunowitz. Bunowitz admitted to putting up Atwater at the Parkhill Apartments when he returned from Florida but only because the latter was suffering from ptomaine poisoning. There was no evidence that he knew Atwater was wanted. He flatly denied ever giving Atwater money or going to see him in Chicago and provided an alibi using his family. The only direct evidence against Potter or Bunowitz was Atwater's testimony, and Atwater had testified in hopes of gaining immunity.

When the jury found Bunowitz guilty, defense attorney James C. Connell moved for a new trial, insisting that the evidence did not support a guilty verdict. He also charged that two members of the jury began talking about Potter's innocence during his trial as soon as they were sworn. "The jury erred," he declared.

Judge Charles R. Sergent dismissed Connell's motion for a new trial, saying, "The mere fact that the jury might have erred in finding Bunowitz guilty and Potter not guilty and that they might have traded Bunowitz for Potter is no ground for granting a new trial."

The jurors said the verdicts were the result of compromise—those who wanted to convict Potter would switch their guilty votes to

Robert Bunowitz was convicted of harboring a fugitive. *Courtesy of the Cleveland Public Library.*

innocent if those who wanted to let Bunowitz walk would switch their votes to guilty. Bunowitz was sentenced to from one to ten years.

A week later, Potter and Taylor faced charges of profiting from a city contract. Prosecutor Miller used Atwater again in this trial. This time, his testimony failed to move the jury. And Miller could not get the Schooleys to talk. Potter and Taylor were found innocent.

In January 1931, Bunowitz—the only person convicted in the Coit and St. Clair land scandal and dubbed by the *Plain Dealer* as the "goat" in the deal—decided to talk to the grand jury. He repudiated his testimony from his own trial and named Potter as a co-conspirator in the Atwater harboring.

The grand jury did exactly what Miller had hoped. It returned a true bill against Rarin' Bill for perjury. It was a two-count indictment, one for each previous trial.

"I haven't got a lawyer yet. It costs money to hire lawyers, and this last year has been a pretty tough one," Potter said at his arraignment. "But I'm ready to go to trial tomorrow if necessary." Judge Walter McMahon wanted to set bond at $5,000, but lowered it to $3,500 when Potter assured the court, "I'll be here anytime I'm wanted." The bond was never needed.

Up to this point, Potter always seemed to have money even if no one else did, but after three court trials, his funds were running low. He was forty-five years old and growing weary of legal battles. It was whispered that he wanted payment to keep his mouth shut about others who were involved in the land deal.

On Tuesday morning, February 3, 1931, Potter left his house on Rudwick Road in a good mood, his wife, Beatrice, said. That same afternoon at 4:20 p.m., he called her and said, "I have a business engagement and I won't be home for dinner. Don't wait for me." She never saw or heard from her husband again.

The following Friday, a woman named Margaret Laub called to tell Beatrice her husband's small coupe had been sitting on Parkwood Drive for several days. Laub's husband managed the Parkwood Apartments at 880 Parkwood Drive Northeast, a less-than-desirable neighborhood. She was a nosey woman who had peered through the windows of the car and saw the name W.E. Potter on a bundle of papers. Beatrice had the car towed and, over the next two days, called the police twice to report her husband missing, both times asking that it not be made public.

Margaret Laub had also noticed a light burning for several days in apartment 4. She went to investigate on Sunday and found the door unlocked. To her horror, Rarin' Bill Potter's bloody, lifeless body was sprawled on the couch.

Inspector Cornelius Cody and deputy inspector Charles O. Nevel worked the death scene. It looked as though Potter had been ambushed as he walked in the door, or perhaps he had been sitting on the sofa when he was attacked from behind. He had been bashed in the head and shot three times, once in the head, once in the chest and once in the arm.

Detectives retrieved a badly distorted slug from the wall. Circled in pencil on the wallpaper above the fireplace was the number and letters "1 S.R." An ordinary shirt button was found next to Potter's body, perhaps torn from the murderer's cuff during a struggle. It was a worthless clue unless they could find the shirt it was ripped from.

They tried to piece together whether Potter was beaten over the head and then shot, the bullet from the wall was fired first to maybe frighten Potter or

there was a struggle and the gun went off. No one in the immediate vicinity heard anything, so police believed the slayer used a silencer. The coroner believed it happened on Tuesday, February 3.

They found a poem in Potter's pocket but had no idea whether it meant anything to the case. It was a simple verse torn from the newspaper that read:

A Little Poem
Member of Bricklayers No. 5
Real songs of love I cannot sing
Sweet things I've always missed;
I do not know why lovers cling,
So far I've never kissed.
While walking by I wonder why
Few pretty maidens care
To smile on me, the few I see
Are very, very rare.
But once a little maiden fair
Made eyes and smiled on me.
I whispered with a soft accent
"Your charms are good to see."
She said: "I like you too:
If you don't care, we'll make a pair.
I give myself to you."

A letter from a former assistant prosecutor was also found on his body. It asked Potter to pay toward a bill for stenographer fees during the land deal trial, further evidence that Potter was short on money.

The evening Rarin' Bill's body was found, the phone rang at the Potter house. One of his daughters answered. On the other end was a loud, screeching laugh.

Fred Thomas, who viewed the body at the morgue, later told a fellow city worker that he had never seen anything like it. "I couldn't have taken an oath that it was Potter. His...it was awful."

Thomas was a longtime friend of Potter's and felt that he knew him well. He told authorities his friend would not have gone to that apartment unless he knew the person he was meeting. Thomas also reported seeing two men from Detroit around city hall. They asked for Potter on the Monday before he disappeared and lingered for several hours. When Potter did not show, they left a business card.

"Yeah, I saw those two fellows," Potter said when he showed up on Tuesday. He tore up the card and threw it away.

Potter was scheduled to go on trial for perjury the day after he was found. Prosecutor Miller and the detectives started thinking that Potter was going to come clean during the perjury trial, maybe even cut a deal and name names of everyone who was involved in the Coit and St. Clair scandal. Whoever was waiting for him in that apartment had different ideas.

Detectives canvassed the Parkwood Apartments and found Mrs. Joseph Berger, whose back door looked directly into apartment no. 4's kitchen. She claimed to have seen a small dark man and a blond woman in a black dress looking out the kitchen window of the "death apartment" on Tuesday at about 6:30 p.m.

Fred Laub told detectives he rented the apartment on January 28 to a well-dressed, dark-complexioned man who gave his name as M.J. Markus. Police assumed the blond woman was his wife.

Police had little to go on, but they kept going back to the blond woman and wondered if she had been used to lure Potter to the apartment. Neighbors said they had seen the blond woman going in and out of the apartment building, as well as in a car of "distinctive color."

Rumors floated around city hall and throughout the police department that the body found at 880 Parkwood Drive Northeast was not Potter, but the coroner had matched dental records. And further, from interviews with friends and family, authorities were now fairly certain that he died on Tuesday, February 3, after 7:00 p.m.

Talk at city hall centered on the idea that the murderer was a professional from New York or Chicago. One of the detectives countered the idea by saying professionals do not bash people's heads in and leave stray bullets in the walls. Furthermore, they do not let people get a look at them by renting apartments.

Inspector Cody started to think the slaying could have been a "racketeer murder," and he followed up on a lead that he thought connected Markus to the two men from Detroit. A few days later, he learned that the real M.J. Markus, a racketeer from Cincinnati, had been dead for a month.

Cody and Chief George J. Matowitz then started looking at the political hookup with the East 105th Street gangsters who were often called in to help during an election. Neither officer would elaborate on where they got that information. "Potter had his finger in everything that would bring him money," Matowitz said.

A taxi driver who picked up a fare on East 105th Street and Morrison Avenue on Tuesday at 6:30 p.m. was questioned. The fare's description fit Markus. The

man went into the building and came right back out with a stylishly dressed young blond woman. The taxi took them back to East 105th Street.

Inspector Cody figured Potter's financial situation must have been dire because Beatrice asked tenants who rented their former home for an advance on rent. She and her husband had moved out of their spacious home to a remodeled bungalow directly behind their former home.

Cody and two other detectives went to Potter's home to speak with his wife and to look at his personal papers. Beatrice refused to let them go through his desk. Her attorney, William J. Corrigan, told the detectives that he had looked through the papers and there was nothing in them that could help solve his murder.

They did learn from neighbors that there had been break-ins as well as beggars in the neighborhood.

While authorities looked toward Detroit for Potter's murderer, Cleveland city law director Harold Burton looked to see if the city could offer a reward. City council drafted a resolution authorizing a $5,000 reward for information leading to an arrest.

The murder weapon turned up in the possession of a police officer named Harry O. Mizer. On the morning of February 4, a citizen found the .38-caliber gun not far from the Parkwood apartment where Potter was murdered and turned it in to Mizer, who had thought nothing of it and failed to turn it over as evidence.

The butt of the gun contained blood and hair. The hair was similar in texture to the hair found on the sofa where Potter had died. The ballistics expert could not match the bullets to the gun because they were too distorted.

After some investigation into Mizer's background, it was found that a Cleveland bootlegger had helped him get on the force. Mizer was immediately fired.

Finally, police got a name. It came from the lips of a pretty bobbed-haired blonde, Betty Gray, who lived with a gangster, J.J. Redlick, in the apartment downstairs. It turned out she had spent some time in Pittsburgh as a hooker. Under questioning, she admitted knowing the man she had seen in the building hallway as "Hymie from Pittsburgh."

Pittsburgh police were well acquainted with twenty-eight-year-old Hyman Martin. To them, he was no more than an expensively dressed ladies' man, a two-bit hood and bootlegger. They did have photos and provided them to Cleveland officers.

When Detective Bernard Wolf showed Martin's pictures to witnesses at the Parkwood Apartments, they all recognized him. Laub positively

identified Martin as the man who rented the apartment. Sixteen-year-old Queen Esther Morgan, also a resident of Parkwood Apartments, was sure she had seen him in the building. A beat cop identified Martin as one of two men he saw talking to Potter on the afternoon of February 3.

Martin was asked to come to meet with police near the Passavant Hospital in Pittsburgh. He complied because he thought they wanted to talk to him about some stolen jewelry. Instead, he was there to face Cleveland detective James Hogan and Cuyahoga County detective John Toner and to answer questions about Potter's murder.

Although some of the witnesses had said the man they saw was a small, dark man, Martin was tall. He also had a space between his front teeth, which none of the witnesses mentioned.

Martin insisted he did not know Potter. He denied renting the apartment where Potter was murdered and said he did not even know where it was.

While in police custody, he tried to hand his keys to a friend. Police grabbed the keys, and Cleveland detective Wolf later tried them in the Parkwood apartment's lock, but none fit. Investigators found Martin's car, a dark blue Nash, which was believed to have been sitting outside the apartment where Potter was murdered. They went over it with a fine-toothed comb and found nothing.

They searched his and his parents' homes and a building where police thought Martin and his racketeer friends met. They came up empty-handed for evidence of Potter's murder but found freshly printed whiskey labels.

"Pittsburgh Hymie" was not about to go to Cleveland quietly. This was a death penalty case and he knew it, so he hired attorney Samuel S. Rosenberg to fight extradition and file a petition for a writ of habeas corpus in the Allegheny County Common Pleas Court. It charged that Martin had been illegally arrested and was illegally held.

Cleveland police were getting tired of the legal delays. They were afraid if they waited any longer, they could lose Martin in more legal maneuvers. Wolf and Hogan decided to act. They snatched Martin, shoved him into a waiting car and drove nonstop to the Cleveland Justice Center.

This angered Pittsburgh judge Joseph Stadtfeld, who had yet to sign the journal entry for the habeas corpus. He called it a "kidnapping of the prisoner as the most indecent haste indicative of extreme disrespect for this court." He said he would not sign the paperwork until the Cleveland officers appeared before him. He ordered the state police to stop the detectives on the road, but the Cleveland detectives had gotten away. The judge never signed the journal entry.

Miller and Wolf were interested in talking to Martin's girlfriend, Mary Outland Woodfield, also known as "Akron Mary." They figured she was the

Left to right: Cleveland police detectives Joseph Koelliken, Bernard Wolf and James Hogan with a hatless Pittsburgh Hymie Martin. *Courtesy of the Cleveland Public Library.*

blond woman seen in the kitchen window of the "death apartment." But she went on the lam.

Miller said he would guarantee Mary's safety and treat her courteously if she would come out of hiding and tell what she knew about the murder. Police put on a two-state dragnet looking for her—to no avail. She was so well hidden that the authorities began to think someone had "taken her for a ride."

Miller subpoenaed thirty-one witnesses to testify in front of the grand jury. They included detectives, patrolman, family members, members of city hall, tenants of Parkwood Apartments, known friends and past enemies. The tenants identified Martin as the man who rented the death apartment. The supposed weapon was introduced through the man who found it in the street. One particularly interesting testimony was given by common pleas court judge George B. Harris, who told jurors that Potter had been in his office shortly before his death and threatened to take others to the penitentiary with him if he was convicted of perjury.

Miller secured an indictment against Martin, but he had yet to find a clear motive. Cody talked with Beatrice again but got no new information. She was at a loss for any motive. According to the *Plain Dealer*, Cody said, "I am

Pittsburgh Hymie Martin playing cards in his jail cell. *Courtesy of the Cleveland Public Library.*

convinced that the deal that led to Potter's murder was one that he kept secret from his family."

After a month of searching, and just as Martin was about to go on trial, police found Akron Mary in a Pittsburgh apartment under the care of two of Hymie's friends. Mary was not blond; she had dark hair. They brought her to Cleveland and held her as a material witness in a hospital cell in the Central Police Station.

When questioned, she came up with different stories. She said, "My Hymie wouldn't hurt a fly" and claimed that he never owned a gun. After speaking with her attorney, she gave her story.

The trial commenced on March 24 with seven men and five women in the jury box. Rosenberg and William E. Minshall defended Martin.

The prosecution's star witness was Betty Gray. On the stand, she told of seeing Hymie from Pittsburgh in the hallway of the apartment complex. On at least one occasion, he had locked himself out and she helped him gain entrance.

Mary was called to the stand by the defense. Stylishly dressed in a black velvet dress, black coat and hat, she took an oath to tell the truth and nervously related how in the beginning of February, Martin had been in Cleveland when he sent her money to come by train to meet him. She arrived on February 2, and after registering at the Auditorium Hotel as Mr. and Mrs. H. Chambers (Mary's maiden name), she and Martin went to dinner with his friends. The next day, February 3, Mary and the friend's wife went shopping while Martin did "business." The two lovers met up at four o'clock that afternoon at the Hotel Winton and drove to Akron, where they registered at the Anthony Wayne Hotel. Miller introduced a hotel receipt that showed they checked in much later.

On April 3, the jury came back with a verdict. They recommended mercy. Five guards brought Martin into court to hear his fate.

Martin had remained poker-faced throughout the proceedings, but when the jury brought in a guilty plea, the veneer cracked and his face twisted into a grimace. Back in his cell, he admitted that he was glad it was over. He asked Sheriff John Siltzmann if a rabbi would come in for holiday services.

Miller was high on victory. "This conviction only marks the beginning of the investigation of the murder," he told the *Plain Dealer*. He was certain Martin had an accomplice. He pointed to evidence that in the days leading up to the murder, Martin had been associated with a "shadowy figure" named Louis Klein—aliases Louis Reddy, Charles Marks and Harry Collins—at the Hotel Winton.

Police uncovered the man's real name to be Louis Rothkopf, but they did not begin looking for him until after Martin's conviction. By that time, Rothkopf had disappeared, and police thought he might even be dead.

In a February 1932 affidavit, Betty Gray repudiated her testimony that she had seen Martin in the apartment building. The judge in the case refused to take her new statement seriously and called her a perjurer. Then she disappeared.

Martin's attorneys, Minshall, Elmer E. McNulty and Harold Mosier, carried his case to the Lima Court of Appeals, which granted a new trial. The State Supreme Court upheld the ruling.

Miller was now Cleveland's mayor, so Frank T. Cullitan prosecuted Martin this time. The state had no new evidence, and its hands were tied when the appellate court held that during the second trial, the state was not allowed to

Ray T. Miller prosecuted all the land scandal figures, as well as Pittsburgh Hymie Martin. *Courtesy of the Cleveland Public Library.*

introduce Potter's land deals as an explanation for his murder. The defense successfully showed that prosecution witnesses, especially Laub, had been paid for their testimony. Detective Cody defended cash changing hands from authorities to some witnesses as a means to keep them in town. He pointed to the fact that Betty Gray had skipped.

It took the jury exactly one hour and ten minutes to acquit Martin this time. He smiled and stuffed a stick of gum in his mouth.

In the end, so many questions remained. No one was ever held accountable for Rarin' Bill Potter's murder.

But eighty years later, a member of Akron Mary's family related that Mary always knew "her Hymie" was innocent.

GUNNED DOWN IN COLD BLOOD

Patrolman Harry C. Beasley holstered his Colt .45 revolver and strapped on his cross-draw gun belt for the last time on Tuesday, June 30, 1931. It was shortly after 5:00 p.m. when he walked out of the police station on West Main Street in Newark, Ohio, to begin his shift that should have lasted until 1:00 a.m.

The night started out like any other on his regular downtown beat. The air was sweltering, but other than that, nothing seemed out of place around the south side of Courthouse Square. Everything was quiet until right around 9:15 p.m.

Beasley turned off South Third Street and headed toward the Rutledge alley running east and west behind the 25–27 South Park Place stores that faced the courthouse. It is possible that he saw the glow of lights where there should have been darkness coming from a narrow alley by the Miller warehouse behind the Newark Bargain Shoe Store and Cornell's retail store.

As Beasley rounded the corner, he saw a car facing west, engine running. The headlights blinded him and made him a perfect target. Two shots punched through the thick night air. One bullet pierced Beasley's chest. The other hit him in the ankle. As he went down, he saw two dark figures hauling a safe out of the back door of the shoe store. He ripped his gun from its holster and returned fire in the direction of the muzzle flashes. The thugs dropped the safe, scrambled into their car and made their getaway, turning onto Third Street. There was no way to tell whether Beasley, an expert marksman, hit either of the gunmen.

Patrolman Harry C. Beasley was shot down when he interrupted thieves stealing a safe. *Courtesy of the Newark Division of Police. Sergeant Al Shaffer, photographer.*

According to the *Newark Advocate*, a few people were still outside, sitting on the park benches at the Courthouse Square. When they first heard the loud *pop pop* sound, they thought it was backfire from a car or firecrackers set off before July 4. Evidently, some people saw the car but failed to get a make or model.

Someone ran to the police station for help. Within a short period of time, both on-duty and off-duty police swarmed the scene. Beasley was taken to Newark City Hospital in the Criss ambulance.

Drs. Carl J. Evans, L.A. Mitchell and Victor Turner took numerous X-rays to determine the path of the bullet that entered the right side of Beasley's chest. The X-rays showed the slug had passed through his lung, splintered the twelfth vertebrae and finally lodged against his spine, producing paralysis from the waist down. The doctors did not want to take the chance of operating to remove it.

"I was trying the rear store doors when I saw the two men emerge from the shoe store with the safe. When they saw me, one fired two shots," the forty-year-old Beasley told a hospital attaché, who relayed his statement to the *Columbus Dispatch*.

"I fell to the ground and was unable to rise, but I fired five shots at them as they fled down the alley," he said. He was not able to give a description of the shooters.

Officer John M. Jones said Beasley and the thieves were approximately thirty feet apart when the gun battle started. He said one of the burglars shot first. He was of the opinion that Beasley recognized the bandits. He told the papers that Beasley did not talk much because he thought he was going to recover and "go get the men himself."

Harry Beasley served as a "Bluejacket" aboard the USS *Florida* during the occupation of Veracruz in 1914. *Courtesy of the Library of Congress.*

Beasley was no stranger to peril when he joined the Newark Police Department on March 23, 1926. As 1 of the 285 armed navy seamen known as "Bluejackets" from the USS *Florida*, he had distinguished himself during a firefight when he took part in the United States occupation of Veracruz on April 21, 1914.

Led by Ensign George M. Lowry, Beasley's company went ashore on a mission to capture the customhouse, where weaponry was stored. Shortly after landing, the company was pinned down by enemy fire. Lowry did not want to risk his landing party, so he asked for a few men to volunteer to advance to the customhouse through a narrow side alley.

Beasley volunteered, along with four of his shipmates: coxswain J.F. Schumaker; boatswain's mate, second class, Joseph G. Harner; Stark County (Louisville) resident seaman Lawrence C. Sinnett; and boatswain's mate, second class, George Cregan. Lowry led the men into a confined alleyway where they were peppered with rifle fire from the custom building and blasted with machine gun fire from a nearby hotel.

One bullet snapped off a button from Lowry's hat. A second grazed one of his legs. Beasley received a slight wound, but Schumaker was shot through the head.

Once the remaining four men had picked off the snipers, a medic made his way down the alley to aid and evacuate Schumaker, who later died. Lowry, Beasley, Harner, Sinnett and Cregan continued down the alley and scaled the wall around the customhouse. They crashed through a window of the building itself, causing the enemies inside to give up.

Beasley was commended for his "conspicuous courage, coolness and skill, which were in accord with and added to the best tradition of the naval service." In additional to being decorated with the Congressional Medal of Honor, he was given $100. Fifty-five other men were also given the award for their part in the capture of Veracruz.

Shortly after Veracruz, Beasley left the navy, only to reenlist during World War I. He served until 1921. Besides the Medal of Honor, he was awarded the Good Conduct Medal, the World War I Victory Medal and the Navy Expedition Medal. After the war, he left the navy with the rank of chief petty officer. His medals are on display at the Newark Police Department.

Whether it was skill, or luck, that delivered Beasley from harm in Veracruz and during World War I, neither skill nor luck was enough to protect him in that back alley on that sizzling hot night in Newark.

Dr. Evans had stayed with the fallen officer for several hours. Around 11:00 a.m. on July 2, Beasley slipped into unconsciousness, and Evans determined he was not going to live. At 12:30 p.m., with his family around him, Officer Harry Beasley succumbed to his wounds. "Death dramatically ended the life of one of the most brilliant officers on the Newark police force," Chief A.E. McMaster told the *Advocate*.

Esther, Beasley's wife, was inconsolable. They had married in 1917, just before he reenlisted for duty in World War I. They had no children. He had two sisters, Marguerite Baker and Bernace Stouch of Newark, and two brothers, Samuel of Canton and Arthur, a prison guard at Columbus. His parents, Charles and Alice of Massillon, were still living.

A post-mortem revealed that the bullet that shattered the bones in his ankle was a .32 caliber. The piece of lead that lodged against his spine and led to his death was a .38 caliber. The different calibers confirmed two shooters.

The shoe store's safe was heavy, so it would have taken at least two men to drag it the sixty-five feet out of the store, then along seventy-two feet into the alley where police found it. Detectives wondered if a third person may have been waiting in the car as a lookout and driver. The safe was not opened and still contained $500.

The thieves had used a crowbar to force open the door of the shoe store. They emptied the cash register of all its money, except for one penny.

Beasley was found lying ten feet from the safe. His shots took an upward trajectory. Two slugs were lodged in the outer walls of the shoe store and Cornell's. The best evidence came when Officer Harry Bragg lifted four fingerprints off the safe.

Safecrackers were sometimes called yeggs at the time, and there had been a rash of yeggs crimes in central Ohio. Clues were few in the Newark case, but authorities hoped the offer of a $1,000 reward would help bring the culprits to justice.

Newark police spread their investigation out over the whole state. They sought help from other jurisdictions and took the slimmest of tips and leads into consideration.

Chillicothe authorities pulled over William Murphy and John Dean for a minor infringement and found two empty shells in their car, along with a gun. Officers thought it had recently been fired. The two men said they had nothing to do with Beasley's shooting and claimed to have spent the night of June 30 in Columbus. They were released from police custody after Newark chief of detectives Curt Berry and officers Charles Connor and Clyde Hupp could not match their fingerprints to those found on the safe.

Columbus police nabbed two other men for attempting to steal a safe from the Columbus Nash Company. Jack Gates and Byrd Daniels were caught red-handed in the alley outside the motor company building. Gates, out on parole from another safe job, and his partner were unable to open the safe and take its $500, so they were putting it in their car. This sounded like a solid lead to Newark investigators, who went to interrogate the two prisoners, but it turned into another dead end.

Police in Columbus shot a suspected car thief, thinking he might have information on the murder. Newark police questioned him at length, but they came away with nothing. Two other Columbus suspects were picked up and subjected to fierce questioning. Their alibis checked out, so they were cleared of the murder; however, during questioning, they admitted to a long string of burglaries.

One evening, as three Newark officers patrolled downtown, they saw a car parked on the square with a hole in its body that looked like it came from a bullet. Knowing Beasley had shot five bullets and detectives had recovered only two, the officers wondered if this car might contain one of Beasley's bullets. They rounded up the owner, who was a young Buckeye Lake man. After considerable questioning, they released him, confident he had nothing to do with Beasley's murder.

In Zanesville, prisoners cleaning up the canal bed behind the police department came across a small iron safe that had been broken open. It was identified as belonging to the Boston Store, a business not far from the Newark Bargain Shoes. Missing for five weeks, the now empty safe had once contained $350. Unfortunately, it provided no tangible new clues.

Three Zanesville men, two of whom had served time in the penitentiary, were picked up because they had a gun in their car. Newark officers Hupp and Connor went to question them but ultimately let them go because the fingerprints did not match.

"We will not stop one minute," Chief Detective Berry told the *Advocate*, "until we have exhausted every clue and followed every possible solution to clear this thing up in order to bring these criminals to court."

At one point, rumors circulated that a group of local citizens were looking to secure the services of private detective Ora Slater from Cincinnati. Slater had worked unsuccessfully on the Melvin Horst disappearance in Orrville but had helped solve and convict high-ranking police officials in the Donald Mellett murder in Canton. For whatever reason, Slater did not enter the Beasley case.

On July 6, 1931, Patrolman Harry Beasley was buried with full military honors. Flags were lowered to half staff, and local businesses closed down from 2:00 to 3:00 p.m. for the funeral.

It was the largest funeral Newark had ever seen, attended by more than two thousand mourners, including Ohio governor George White. It was reported in the *Advocate* that the governor told the crowd that Beasley's "assassins must be brought to justice to avenge American society." He went on to say, "Society should pay its respects to the officer who was shot down by outlawry after he had escaped the ravages of war."

The service was held at the First Methodist Church, where Dr. L.C. Sparks gave the eulogy. He said Beasley had given "his life in the protection of life and property of other people." Grace Cranston played a selection of sacred music on the organ. The procession was led down Newark's downtown streets by the Knights of Pythias band. Thousands of flowers had been made into funeral sprays. They filled cars and lined the procession route. The full Newark police force, as well as firefighters, servicemen and veterans, followed the hearse. Police from across the state came to pay respects to a fallen brother who had been gunned down in cold blood. A tearful Newark citizenry watched the procession in respectful silence from the sidewalks.

It took a half hour for the full cortège to pass through the entrance of Cedar Hill Cemetery. Six of Beasley's fellow officers carried the flag-draped

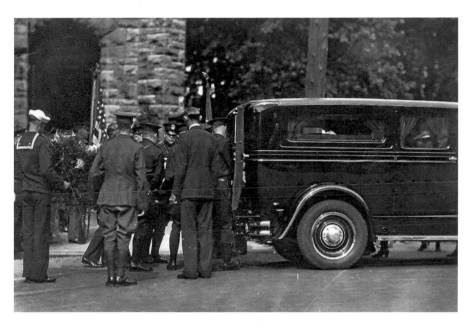

Beasley's hearse in front of the First Methodist Church. *Courtesy of the Licking County Historical Society.*

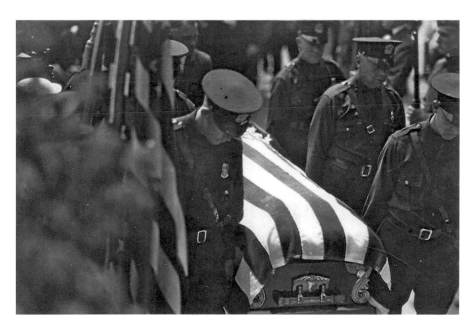

Officers carried Beasley's flag-draped coffin in the funeral cortege. *Courtesy of the Licking County Historical Society.*

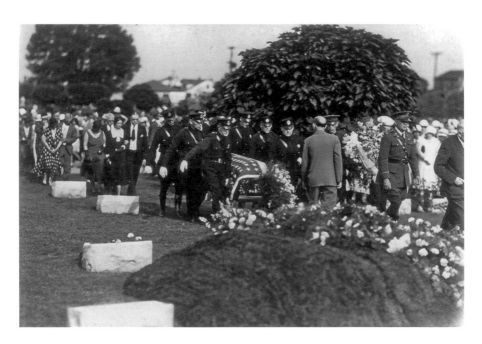

Officers carried Beasley's flag-draped coffin to his grave at the Cedar Hill Cemetery in Newark. *Courtesy of the Licking County Historical Society.*

coffin to the grave site. The simple graveside ceremony ended with taps and a rifle volley from the Ohio National Guard.

While leads would pop up now and then—one from as far away as Washington, D.C.—along with police corruption and conspiracy theories, the murder was never solved. The case file disappeared in the 1940s, according to an article by Jim Leeke in the October/December issue of *Timeline*.

To this day, no one knows who shot and killed Patrolman Harry C. Beasley. The only thing for certain is the thieves did not get away with the safe on that hot June night, but they clearly got away with murder.

A DEADLY AFFAIR

The last thing Rose Cable did every night before bed was take the canary cage out of the breakfast room window, set it on the table and cover it with a cloth. Thursday evening, March 11, 1937, was the last time she would ever carry out this routine. At 11:18 p.m., birdshot blasted through the window, peppering the society matron on the left side of the head and neck.

Rose's seventy-one-year-old mother, Pauline Beiter, was standing in the kitchen when she heard the gunshot, the glass breaking and her daughter's shriek all at the same time. She rushed into the breakfast room to find Rose pitched forward on the floor with blood pooling around her head. At first, Pauline did not realize her daughter had been shot. To her, it looked as though she was hemorrhaging from her head.

She ran next door to get help from the neighbors. Young Sarah Gaston answered the older woman's plea and hurried with her back to the Cable house. She, too, did not realize Rose had been shot. She called the police and asked to have a physician sent to the house. In a matter of minutes, Sarah's parents and Mr. and Mrs. John Keller, neighbors from two doors down, came to help.

Keller picked Rose up and saw the wounds in her neck. He told Mrs. Gaston to call the police back and tell them Rose had been shot. Shortly after midnight, two detectives arrived at the Canton Tudor-style mansion on Fulton Road Northwest. The C.D. Spiker ambulance responded and took Rose to Mercy Hospital, where the forty-seven-year-old woman died from blood loss. The birdshot had punctured her jugular vein.

Wealthy society matron Rose Cable was shot through the breakfast room window. *Courtesy of the Cleveland Public Library.*

At the start, police concentrated their investigation on a man's size ten and a half footprints outside the breakfast room window. The prints were from shoes of a popular style with treads on a rubber heel.

Harry A. Anderson, Rose's cousin, had visited the house earlier that evening and left shortly before the shooting. Police seized on this information and took the thirty-six-year-old into custody for questioning around 1:30 a.m. Upon leaving the Cable home, Anderson said he looked for a bus up and down Fulton Road but saw none. He walked to the corner of Fulton and Fourteenth, where the 11:00 p.m. bus picked him up. When he got off the bus, he went to a drugstore and bought some cigarettes before going to his room at the YMCA and going to bed.

Rose's wealthy husband, forty-eight-year-old Dueber S. Cable, was the president of Cable Company Inc., a contracting firm. He was working on a job in Cleveland, supervising the excavation for a new Republic Steel mill. That evening, he was staying at the Carter House and was with friends in the barroom from 9:00 p.m. until 1:00 a.m., when he went to his room. Around 2:00 a.m., he got word of what had happened and immediately drove home.

The couple had two children: Jane, a student at Heidelberg College, and Hobart, a student at Riverside Military Academy in Gainesville, Florida.

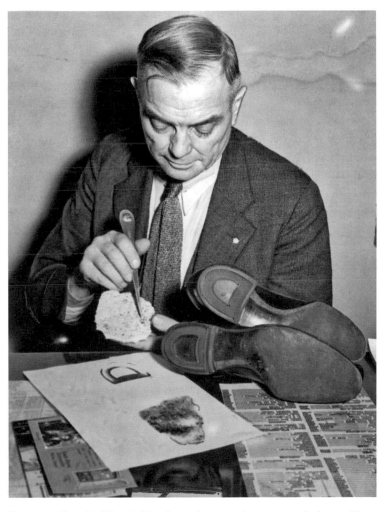

Canton police chief Ira A. Manderaugh comparing a suspect's shoes with plaster cast and ink prints. *Courtesy of the Cleveland Public Library.*

Both Dueber and Pauline expressed surprise at the police interest in Harry Anderson. They insisted that he had nothing to do with the Rose's killing and strongly urged the police to release him.

Anderson had been detained all day Friday until noon on Saturday. He fully cooperated with investigators, telling them he did not see anyone outside the house and did not hear the shot.

Detectives made a plaster cast of the shoe print outside the breakfast room window of Cable's home. While the measurement was similar to that of Anderson's shoes, investigators had to admit that many men wore the same size. The bus driver, as well as the drugstore clerk, verified Anderson's alibi.

Authorities were at a standstill until twelve-year-old Elden Yost, who lived in the area, found an empty shell from a .410-gauge gun just west of Lake Cable. Not knowing that it was important, he carried it around in his pocket for a few days before showing it to his father. A neighbor had read about the murder in the paper and thought the shell should be turned over to the police. Detectives figured the shell could be relevant because it was not weathered and looked as if it had been fired recently. Did the killer live around Lake Cable?

It just so happened that the shell resembled ones that had been stolen, along with a pistol-type .410-gauge "game killer" gun with a short barrel, from Dueber Cable's car several months before his wife's murder. He freely admitted he had owned such a gun. He and friends used it to kill snakes and sparrows. Police called in a local gun expert to do some test fires. The expert found that a .410-gauge gun would not scatter the lead in the same pattern as had hit Rose. He guessed the gun used to kill her was a .12-gauge sawed-off shotgun, or some unusual model. However, Cleveland Police Department's ballistics expert David Cowles's tests showed that the gun was indeed a .410-caliber shotgun.

Police combed the area around Lake Cable for any footprints that might match those outside the breakfast room window. Maybe if they were lucky, they would find the gun. The lake was covered by a sheet of ice, and there were no breakages in the surface, so searchers did not think the killer had thrown the gun in the water.

On the theory that the killer would take the fastest escape route, police enlisted the help of thirty Boy Scouts in a systematic search along Fulton Road, through Avondale, down Lake Cable Road to the junction of Lake Cable and McDonaldsville Roads. It was an exercise in futility.

It was not long before Dueber Cable came clean about having an affair with a forty-five-year-old, twice-divorced Akron woman named Mrs. Theresa "Dora" Ludwig Bail. He admitted that since July 1934, he had maintained

Dueber and Ludwig's "love nest" was in the swanky Hill Chateau apartments on East Tallmadge Avenue in Akron. *Courtesy of the Cleveland Public Library.*

a five-room apartment for his paramour at a cost of $200 a month at the swanky Hill Chateau on East Tallmadge Avenue in Akron. Police descended on the apartment and searched it. Dora was not there, but they did find several articles of men's clothing that belonged to Dueber. While there, authorities showed a photo of Dueber to the owners and building tenants, who identified the couple as Mr. and Mrs. John Sherrard.

When an Akron reporter for the *Plain Dealer* asked the owner of the building about the woman who lived there, she said, "She often entertained visitors. I seldom saw her with anyone. I only saw the man known to me as Mr. Sherrard about a half a dozen times."

A neighbor revealed that the so-called Mrs. Sherrard would host parties for three or four other businessmen from Canton and Akron and their girlfriends. The owner of the building said the parties were quiet and there were never any complaints.

One of the tenants added, "She was one of the most charming persons I have ever known. She dressed well and wore her clothes beautifully. She

was as charming to her neighbors as she was to women guests who called on her."

As authorities delved into Dora's background, they found she had used four aliases, including Mrs. John Sherrard, Theresa Ludwig, Dora Ludwig and Theresa Bail. In July 1934, she was divorced from her second husband, Carl W. Bail of Canton, and must have moved into the Akron apartment soon after. Detectives also learned she owned part interest in a small downtown Canton dress shop and continued to work at the shop until sometime in 1936.

On the morning of the murder, Dueber had stopped by Dora's apartment for breakfast before going to work. Before he left for Cleveland, he called an auto dealership and ordered a new car to be delivered to his wife on Saturday for her birthday. A report in the *Plain Dealer* said he and Dora had a bitter quarrel over the new car. But in the past, Dueber had bought his lover four new cars.

When later asked about that morning, Dora recalled it differently. She said Dueber had made several calls from her apartment. She was in the kitchen cleaning up, though, and did not know to whom he was talking or what he talked about.

During the investigation, detectives found that Dora owned a 1937 black Dodge coupe. Two fifteen-year-old Lehman High School girls had seen a dark coupe several times on Fulton Road Northwest. One of the girls, Betty Chaffin, lived next door to the Cables. Her friend, Elizabeth Kratz, was at Chaffin's visiting. The car drew the girls' attention when they saw it drive by the Cable home on the Wednesday night before the murder. They watched it from the front window as it circled around the block several times. The girls said they saw the same car again on Thursday night. This time, its lights were out as it crept slowly past the Cable house. This was less than half an hour before the girls heard the shotgun fire.

Dueber also had a black Dodge coupe, but one of his employees had driven his car to another part of the state sometime before the day of the murder.

Detectives found Dora in Steubenville. She had driven there the day after the murder to visit her friend Bertha Mumaw. She was taken into custody and brought back to Canton, held and aggressively questioned all weekend by Stark County prosecutor A.C.L. Barthelmeh and Canton detective Captain Elmer E. Clark.

Dora had no alibi, having spent both Wednesday and Thursday nights home alone. She did not feel well on Thursday evening and went to bed at 9:30 p.m., she told her questioners. Shortly before retiring that evening, she called and talked to a friend in Akron and then called a second friend

Theresa Dora Ludwig's 1936 black Dodge coupe. *Courtesy of the Cleveland Public Library.*

in Canton. When police accused her of driving past the Cable home on the two nights in question, she insisted that her car had been parked in the garage and had not moved either of those nights. When police checked with tenants, none had seen Dora around the apartment building on those evenings. That was not unusual, however, because she was not neighborly. Authorities spoke with Dora's two friends and ascertained the phone calls had been made that night sometime between 8:00 and 8:30 p.m.

Dora said she left Akron for Steubenville at 9:30 a.m. on Friday. She was going to help Bertha Mumaw, who had injured her ankle and was having trouble taking care of her husband, who was ill. Dora arrived there about mid-afternoon. Before she left Akron, she tried calling Dueber at his office but was told he had gone home to Canton. She was given no explanation. She and Dueber had planned to have dinner Friday evening, so she wanted to get hold of him to let him know she would be unable to keep their date. She called a "prominent Canton businessman," whose name turned out to be Lester H. Higgins, to have him call Dueber. Higgins was a business advisor and close personal friend to Dueber. Nothing was said about the murder during the conversation.

That evening while Dora was in Steubenville, a friend called about the murder. The friend read a newspaper article to her over the phone. Dora then got hold of the *Steubenville Herald Star* to read it for herself. The murder upset her, and she cried after reading about it because she felt badly for Dueber and the two children. She said to her Steubenville friend, "Well, thank God, I'm innocent of any crime."

The next morning she said she placed a call to Higgins to find out how Dueber was doing. "You had better lay low until this blows over," Higgins told her. "Don't go back to your apartment in Akron." Higgins verified the two phone conversations he had with Dora for police. He and his girlfriend were frequent visitors to the apartment Dueber had rented for Dora. It

Theresa Dora Ludwig, alias Mrs. John Sherrard, was Dueber Cable's mistress. *Courtesy of the Cleveland Public Library.*

came out that four other men and their paramours also used the apartment, or what the newspapers began calling the "love nest."

During Dora's detention and questioning, she was moved about from an all-night interrogation at the prosecutor's office to the home of Detective Bert Minesinger, where she was held in "technical custody." A few days later, she was taken to the Canton city jail, then to Chief Ira A. Manderbaugh's house and back to the city jail. A week after that, police installed her in the hospital ward of the Stark County Jail, where female prisoners were often held. During all the questioning and even a lie detector test, she remained resolute in her story.

Dora talked freely about her affair with Dueber Cable and made it seem like the ideal relationship. Dueber's take was much different. He felt she was not telling the police all she knew. For one thing, Dora had asked him several times if the gun that had been stolen from his car had ever been recovered. He also said they argued about their future.

Visiting hours for Rose were held on Monday, March 15, 1937, at her home. Later in the day, Reverend R.W. Blemker officiated at the funeral service at the First Reformed Church, where Rose had been a devout member. She was buried in Westlawn Cemetery.

Dueber's doctor ordered him to bed rest because of "a serious cardiac condition resulting from the strain of the long questioning Mr. Cable was subjected to Monday night," but the evening after the funeral, police were on his doorstep. The *Plain Dealer* learned he was taken to jail.

Little by little, he added to his story. He had been trying to disengage himself from Dora, he said. In fact, he had told her twice that he wanted to end their affair, including at a party the week before Rose's death and on the morning of the murder.

Because Dora's and Dueber's stories were at odds, Prosecutor Barthelmeh, Detective Clark and Chief Manderbaugh decided to bring the two together to see how their stories stacked up.

Dueber took the opportunity then and there to tell Dora flat out that he was through with her.

Dora was taken aback at Dueber's rejection, but she held on to her story. She elaborated on the quarrel they'd had a week before Rose was murdered. They were at an all-night party at a hotel in Cleveland with three other couples. The men were all business associates, and the women were not their wives but Cleveland girlfriends. The disagreement had to do with one of the girls at the party. Dora threatened to walk out of the party. Dueber told her if she did, they were through. She stayed, and they patched things up, she said.

The next afternoon, she went home to her Akron apartment. Dueber came and went for the next couple days. She denied any talk of them ending their affair. To illustrate, she said he had given her twenty dollars to buy a cocktail table for the apartment, which she then ordered from an Akron store. A salesperson at the store verified the purchase and the date. The table had been delivered and was left outside the apartment door until the custodian moved it inside.

Dora denied ever having asked about the gun.

After two weeks of constant grilling and no formal charges, Dueber was released on a $20,000 bond raised by his brother Austin B. Cable. The next day, the Cable brothers added $3,000 to the $1,000 they had

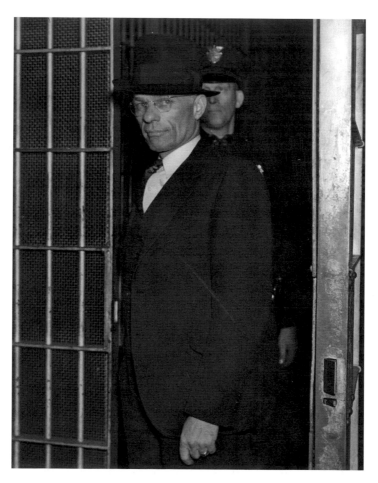

Dueber S. Cable leaving jail. *Courtesy of the Cleveland Public Library.*

already offered as a reward for information leading to the arrest of Rose Cable's murderer.

On April 1, Dora's attorney, William B. Quinn, arranged for her to be released on a $1,000 bail. At her arraignment, she told the judge that she would go to stay with her sister and brother-in-law, George and Edna Rodebaugh, in Conneaut. She was wearing the same green hat and dress and black fur-trimmed coat she was wearing when she was arrested in Steubenville.

Except for a few meager clues, the investigation stalled until May 1938, although Dueber's former lover was still under suspicion.

Austin claimed Dora had called either Dueber or him at least twenty times during the months following her release. Her request was always the same. She wanted "compensation." When Dueber would no longer talk to her, Austin interceded. Early on Saturday night, May 8, she drove to the Cable house on Lake Cable Road where Dueber had been staying with his brother. She sat in her car outside the house until four o'clock on Sunday morning.

Finally, she left and showed up at a friend's house in Canton around 9:00 a.m., where she stayed until 10:00 p.m. During the day, she called Austin Cable's home and made arrangements to go talk with Dueber.

There were guests at the brother's house when she arrived later that night. "I told her that if she would talk quietly we could go into another section of the home and talk. She agreed to not make a scene," Austin told the *Repository*. He led her into another room; Dueber was at least within ear shot, but whether he was in the same room was not made clear in the news article. Austin asked what she wanted. "She insisted that she be taken care of. I asked her what she meant and she replied that since she had given Dueber seven of the best years of her life, she should not now be cast aside." She repeatedly insisted Dueber marry her, but he wanted no part of her.

Austin told Dora he and his brother thought she was responsible for Rose's death. He told her they had evidence that her alibi on the night of the murder was false and that there was a phone record of unanswered calls to her apartment right around the time of the murder. "I added that we had sufficient evidence to put her behind bars," he said.

Dora did not seem to be upset by this and said "it sounded like a reasonable story." Austin told her this was the showdown and that they would no longer tolerate her visits. She began to get loud, saying she would "make them pay."

Austin asked her to leave quietly, but she sat tight. She hissed that she would not go until she had an "understanding." Seated across the room from

him with a large black pocketbook resting in her lap, she dared him to throw her out. He stood up and so did she.

"Dora, you've asked for this." He grabbed her by the arms from behind and shoved her out the rear door. As she got in her car, he told her to never come back.

"You'll hear from me later." She hurled the threat at him as she drove out of the driveway.

The Cable brothers were shaken after the confrontation with Dora and afraid she might come back. Austin decided to call Detective Clark, but there was no answer. He then telephoned the *Repository* and asked for a reporter to come to his home because he wanted someone else to know what had happened.

Dora drove back to her friend's house in Canton but stayed only a few minutes. The friend later told police Dora was wearing a blond wig and it had slid down over her forehead. Dora said it happened when Austin Cable had "pushed her around."

Dora's whereabouts after leaving her friend's house were not known. However, a family member staying at Dueber's home said he heard a car close to the house very early the following morning, May 10, 1938. He looked out the second-story window and saw a black Dodge coupe in the driveway. The car did not stay long. Maybe the driver saw someone in the window, because after a few minutes, it backed away from the house and left.

A few hours later, Dora was at her sister Edna's house in Conneaut. Sometime after her sister and brother-in-law left for work, Dora went out to the garage and locked the door. She carefully stuffed rags in cracks in the garage walls and around the windows. She started the engine of her black Dodge coupe, then lay down on the floor under the rear of the car. She folded her new spring coat into a cone with one end tucked around the tailpipe and the other end covering her face.

Edna came home at lunch and found her sister's body. The car engine was still running.

Dora had left a note for her family telling them how to dispose of her personal property. She had also left a letter addressed to her attorney. On Tuesday evening, Edna and another sister, Blanche, took the letter to Quinn's office. He read it aloud, then turned it over to the prosecutor. The contents were published in the *Repository* on May 11, 1938. Photographs of the letter are in the photo collection files at the Cleveland Public Library. It read:

Conneaut, O., May 9, 1938

Mr. Quinn:

Will you please see that the reward for the Cable murder is gotten and please give it to my sister, Mrs. Edna Rodebaugh at 351 Main st., Conneaut, O.

Mr. Dueber S. Cable had Rose Cable shot on the night of March 11, 1937. The men that did the work was from Cleveland. And that was where he was for the time they could not account for after he left the bar until they got him in his room.

I did not know for sure at time I was questioned. But he had said we would get a brake [sic] and it would not cost him so much only $200 for the job.

I cant go on and not tell it. I cant take the stand and tell this. So I am taking the easy way out.

I have saw Dueber a lot since but after he got back to Canton from Pennsylvania I did not see him so much as he said A.B. Cable raised hell everytime he saw me. As A.B. Cable thought I did the job. And after the way A.B. Cable treated me last night and Dueber was afraid to say any thing to protect me. I maid up my mind to tell all. So I went out and told Claira Griffith the story before I drove back to Conneaut. I told her Dueber had did the job and that I was going to tell all.

Here are some of the dates I have saw him in hotels since. He had me come to Pennsylvania so he thought it best I register under different names.

July 27, 1937 rooms 404 Kimmar hotel, name Nonie Snyder.

Sept. 18 & 19 room 224 Nonie Snyder.

Oct. 15 room 122 name Ann Ziegler.

Oct. 23 dont know room numbers.

Sunday after Thanksgiving meet him in Cleveland. We drove to Butler, Pa., stayed at Willard Hotel, name Mr. and Mrs. Ed Russell.

And I went to Canton on Saturday Dec. stayed at Hotel Onesto.

Dec. 31 Hotel Onesto.

Jan. 1, 1938, Hotel Onesto. Names I don't remember as he ask me to change the name different times. Jan. 21 to 23 we meet in Cleveland, stay at Hotel Olmstead, name I think D.S. Potters & wife. And I have been at Hotel Onesto on Feb. 21 and one time since I cant remember date. But the last time was April 5, 1938 Dora Russell.

It was one party in Cleveland he told me the story about Rose. Hope this is clear to you. Also the court. For I think He should pay the price.

I thought at first I could never tell it. But could not get it off my mind.

As ever,

Theresa Ludwig,

351 Main st.,

Conneaut,

Ohio.

Did Dora tell the truth in this antemortem? Was she a scorned woman out for revenge? Was she mentally unstable? Whatever she was, her letter had the effect she had hoped. Dueber was arrested again and held in jail. He denied knowing anything about the story of hiring hit men.

Dueber's attorney gave little credence to the letter, pointing out that she was under a great deal of mental stress. He thought she had written it out of spite. "She had been newly scorned; and you know the old saying, 'Hell hath no fury like a woman scorned'?" Her mental state was evident in the spelling and grammatical mistakes, he said.

At the Cables' bidding, investigators checked Ohio Bell Telephone long-distance records and verified that Bertha Mumaw had tried to call Dora at her Akron apartment the night of the murder. The records showed that Bertha had tried Dora's unlisted phone three times starting at 10:11 p.m., but there was no answer.

Bertha told authorities that when she finally reached Dora the next morning, she claimed to have had indigestion the night before and had gone to bed early. She had not heard the phone ring because she closed the bedroom door so nothing would disturb her.

Bertha related to a *Repository* reporter that Dora had taken to wearing a blond wig and that she was losing weight in an effort to disguise her identity. She never gave a reason.

After Bertha's husband died, she and Dora took a trip to California. It was on this trip that Bertha witnessed how moody Dora had become. Bertha said she would fly off the handle at small things. During the trip, Dora told Bertha she had taken shooting lessons and had become quite proficient. After the trip, she saw little of Dora.

Before Dora's death, Dueber paid a "friendly" visit to Bertha when he was going through Steubenville on business. He asked if she had seen Dora. She told him she had. This was when Bertha told him she had tried to call Dora the night of Rose's death. Bertha asked Dueber if he had seen Dora. He said no, but Bertha told the reporter she had the feeling that they had seen each other.

After Dora died, detectives went to Cleveland and Youngstown to try to develop leads on hit men and a .410-gauge shotgun, but they would not divulge any additional information. It was learned from Edna Rodebaugh that Dora had said she was going to Youngstown the Friday night before her suicide.

Austin told the *Plain Dealer* that when Dora was questioned right after Rose's murder, she insisted that marrying Dueber in the event of his wife's

death had never crossed her mind, "However, it was not thirty days after Rose Cable was laid in her grave that she made demands of marriage on Dueber." Austin told her if she could solve the murder, he would withdraw his objections to her marrying Dueber.

When police could develop no new leads, they released Dueber Cable, saying they had no justification to hold him any longer. They never found the gun and were never really sure what type of gun was used. And they never had solid proof that Dora had pulled the trigger.

How about the other five men who had an interest in the Akron "love nest"? Police questioned them and were satisfied with their answers. Higgins was the only one named in the papers. The others escaped notoriety.

Was it possible that Rose had found out about the six men and their playmates, and she was killed before she could start trouble?

In February 1939, Dueber Cable married Lola F. Lanich of Whitney Point, New York. They divorced in 1943. He later married Caroline Stockdale. He died in 1954.

CARNIVAL GIRL

S he was young, somewhere between twenty-five and thirty. She was
pretty, with chestnut hair and brown eyes, about five feet, six inches
tall and weighing 125 pounds. And she was dead. Her body was cast off
like some forgotten rag doll in a clump of weeds along State Street, not far
from well-traveled River Road in East Liverpool, a town located in the Ohio
Valley on the Ohio River.

An eighteen-year-old high school football player, Sam Winters, came upon
her body around seven thirty in the morning on Saturday, June 3, 1944. He
worked the night shift at the Pittsburgh Crucible Steel plant in Midland,
Pennsylvania, and had just gotten off the Midland–East Liverpool bus on
Mulberry Street. As he walked along the cutoff that linked River Road and
Hill Road, he saw two bare feet sticking out from under some blankets.
Jarred by the sight, Sam ran to a nearby phone and called the police.

Sergeant Herman Roth was the first to respond. He quickly surveyed the
scene and left Sam to protect it until he could call for more help. Chief Hugh
McDermott, Patrolman Cunningham and Columbiana County coroner
Arnold W. Devon arrived in short order.

Police found the young woman lying on her back about ten feet off the
road not far from the Pittsburgh railroad underpass. Nude except for a
torn pink slip pulled up under her arms, she had been wrapped in two
cheap green blankets that showed some wear and were trussed with what
appeared to be new clothesline. Sheriff George Hayes was also notified
of the murder. He came to the scene and made plaster casts of tire marks

An unidentified female body was found near Ralston's Crossing in the East End of East Liverpool. *Courtesy of Frank "Digger" Dawson, Dawson Funeral Home.*

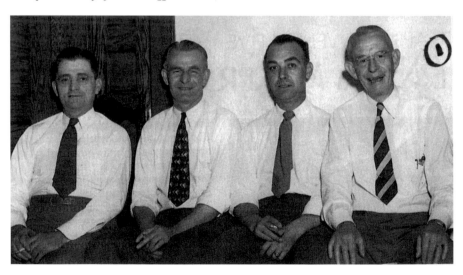

Left to right: East Liverpool's safety director Vince McGeehan, Wilfred Devon, Frank Dawson and Coroner Arnold Devon investigated girl's death. *Courtesy of Frank "Digger" Dawson, Dawson Funeral Home.*

in the cinder roadbed near where the young woman was found. In the event a suspect was found, the casts might be helpful in identifying the car that brought her to that spot.

The young woman was taken to the Dawson Funeral Home, where Coroner Devon performed an autopsy. He found bruises on the left shoulder at the base of her neck. Discoloration on her face indicated that she had been strangled, but Devon was not sure whether she was choked by hand or by rope. He estimated that she died about two hours before she was found because her body was still warm, although he said the blankets could have helped retain body heat. Her ears were pierced, and the only jewelry on her was a pair of small hoop earrings. There was nothing else on her body to identify her.

The funeral home photographed her and prepared her body for burial. East Liverpool police took the photo around to the local businesses, night clubs and beer gardens, but no one recognized her. A few people viewed her body and said her face looked familiar. Even though Chief McDermott thought she was from East Liverpool or Wellsville at first, he sent her fingerprints to the FBI. Word came back from the Washington lab that there were no matches on file.

As tips began filtering into the police station, officers started following the leads. Authorities took a hard look at the Sheesley Carnival, which had been in town, set up at Columbian Park, the previous week and wondered if she could have been a member of the traveling show. When the show pulled out of town, it left clues behind in its trash. A man searching through the refuse for materials to build a tent for his children came across a box that contained two torn dresses and a ripped skirt.

Sheriff Hayes chased down a lead after finding a photo of five "dancing girls" in the carnival's Gay New Yorkers Revue. The photo had been taken at Columbian Park, and one of the young ladies in the picture closely resembled the dead woman. The girl in the picture had failed to show up for two performances in Lima, where the carnival was playing. Hayes set off for Lima, but after talking with carnival personnel, he sent a telegram back to East Liverpool that said the girl in the picture had been accounted for in the show.

After these first leads, the newspapers began calling her "Carnival Girl."

Another clue came from a man who lived on St. George Street, not far from where the young woman was found. It was around 4:10 a.m. on Saturday, and he was putting his car in the garage when he noticed a vehicle out on the road switch its lights off and turn onto State Street near the railroad underpass. The witness was certain the license tags were not blue and white and therefore not from Ohio. He saw no one in the car but the driver.

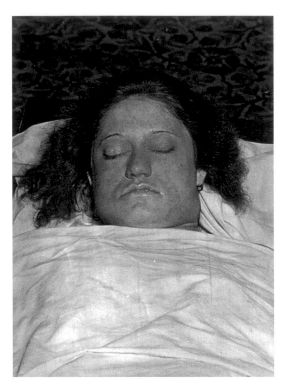

The unidentified "Carnival Girl" of East Liverpool, 1944. *Courtesy of Frank "Digger" Dawson, Dawson Funeral Home.*

Authorities received dozens of calls asking for descriptions about missing loved ones and friends. Calls came from Ohio, Pennsylvania, West Virginia and as far away as South Carolina. None of them panned out. In the end, police were stymied. Without identification, they could not come up with a motive, let alone a suspect.

At least 1,500 people showed up at the funeral home to view her, many out of curiosity, some out of hope of finding a lost family member. The crowds got to be overwhelming, so the funeral home limited viewers to those sent by police. On Tuesday, June 6, Dawson Funeral Home held a simple service.

The unidentified young woman rests in an unmarked grave in Spring Grove Cemetery in East Liverpool. To this day, no one knows who was responsible for her death and no one knows her name. She is just remembered as the "Carnival Girl."

9

LOVE GONE WRONG

It was 6:40 p.m. on Christmas Eve 1959 when a sniper's bullet snuffed out Charles Roy Clark's life. The thirty-five-year-old father of four was standing in front of the kitchen window in his Mentor home, opening a can of pumpkin for his daughter when, out of the darkness, a bullet ripped through the glass pane and struck him in the right temple.

His twelve-year-old daughter was standing close by. His wife, Lois, was baking a pie a few feet away. Lois said that, at first, she thought the can had exploded. "Then he fell and I saw the blood," she told a reporter.

Chuck was a Boy Scout leader of Troop 104, which was connected to the Mentor Methodist Church. Dressed in his Scout uniform, he was ready to take the members of the troop Christmas caroling later that evening. Instead, he died on the way to Lake County Memorial Hospital.

Described by a neighbor as a "wonderful man," Chuck was also the superintendent of the Methodist Church Sunday school. Friends said his aim in life was to steer young boys onto the right path. He was a friendly man with a "good perspective on life." So who would want him dead?

The possibility of a stray bullet was ruled out from the beginning by Mentor police chief Frank D. Hathy, who thought the bullet's trajectory was upward and from a small-caliber gun.

Hathy figured the sniper sneaked up beside a sycamore tree forty-two feet from the kitchen, took aim and pulled the trigger. The ground had frozen over that week, so there were no footprints in the backyard, and no shell casings were found.

A bullet fired through the kitchen window killed Charles Clark. *Courtesy of the Cleveland Public Library.*

From Syracuse, New York, Charles Clark was employed as a design engineer for Reliance Electric & Engineering Company. He was the manager of the technical service division of the company's federal marine section. He had worked for the firm for fifteen years. "He was as highly moral an individual as I've ever known," said his boss.

Although the dead man never graduated from high school, he was on his way up. As the liaison between his company and the Navy Department, he traveled widely and was well known and highly regarded in his field.

Charles Clark was killed by a bullet through the kitchen window. *Courtesy of the Cleveland Public Library.*

The oldest of ten children, Chuck was born in Ogdensburg, New York, to Carl E. and Ethel Clark. They later moved to Rochester, New York.

One week after the Japanese hit Pearl Harbor, he joined the navy a semester short of high school graduation. He spent four years with the navy in Puerto Rico assigned to blimp service.

While on leave in Miami, Florida, he met a beautiful, dark-haired, sixteen-year-old model. Her name was Lois Mae Bravaldo. They fell in love and were married in June 1945. After Chuck's discharge, he and Lois moved

Charles and Lois Clark's home in Mentor. *Courtesy of the Cleveland Public Library.*

back to Rochester, where he went to work for Reliance. Six years later, he was transferred to Ohio.

At the time of Chuck's death, the family had lived in Mentor in a white-frame house on Arcadia Drive for two years. The outside of their house was decorated with colored lights for the holidays. A Christmas tree stood in the dining room surrounded by presents for each of the four children, who ranged in ages from seven to thirteen. "It was an ideal family," said a neighbor.

At least, it looked that way on the outside. The real story was quite different, however.

Lois Clark may have been teaching Sunday school alongside her husband at the Mentor Methodist Church, but she was having an affair with an attractive man named Floyd E. "Gene" Hargrove. The two began their trysts in the spring of 1959. Hargrove, who had been a buyer at Reliance in the past, had known Chuck for several years.

Lois revealed the affair to Sheriff William B. Evans during initial questioning. Evans had been called in to the investigation by Lake County prosecutor Edward R. Ostrander. The widow told Evans she and Hargrove had broken it off six weeks before the shooting. She insisted she never contemplated divorce, adding that she admired and respected Chuck.

"My husband and I got along well," she told a *Cleveland Plain Dealer* reporter.

Lois told the sheriff that she had received anonymous calls in the weeks leading up to her husband's death. The man on the other end of the phone demanded she date him. When she refused, he threatened to tell her husband she was entertaining men at their home while he was at work.

It was true. Hargrove had been a frequent visitor to the Clark home. What she had to tell about her conduct was embarrassing, but she remained calm throughout the questioning, and Evans thought she was being truthful.

Why was she unfaithful, Prosecutor Ostrander asked. She said she was an orphan and, therefore, had no role model for love and marriage. She admitted to affairs with six other men in the past. But they were meaningless, and her husband knew nothing about them. She was in love with "Gene," she said, and could not believe he was a murderer.

According to one of Clark's sisters, Chuck had ordered Hargrove out of the house and told him not to come back when he was not home. Chuck was afraid the neighbors would gossip if they saw a man at their house when he was not there.

Investigators questioned three of Lois's past lovers but concentrated on Hargrove, picking him up only hours after the shooting. He lived in an apartment in Painesville and was employed at Moss Point Cleaners in Willoughby as a delivery truck driver. He was affiliated with the Willo Gospel Chapel.

"I knew what I did was wrong," Hargrove told a *Cleveland Plain Dealer* reporter. He talked of "wrestling with the devil" and having a "big spiritual argument" with himself over the affair.

During his interview with the newspaper, he admitted that right after he and Lois broke it off, he thought about killing Clark and was ashamed of himself for that. While in jail, he said he dreamed of killing Clark. In one dream, Sheriff Evans helped do away with Clark with a bow and arrow.

On Christmas Eve, Hargrove claimed he had dinner with John Ozinga Jr. in Painesville, as he did on many evenings. Ozinga was his boss at the cleaners. He left Ozinga's at 6:30 p.m. and went looking for another friend who worked with him. The cleaners was closed and his friend was not there, so Hargrove drove to the house of another friend, Robert Diday, stopping for gas along the way. Later, he drove to Euclid to see his ex-wife, Beverly, and to give his five children presents.

That was not good enough for Evans. He calculated a twenty-minute span that Hargrove did not account for.

Beverly Hargrove, an attractive thirty-two-year-old blonde, had nothing good to say about her ex-husband, but she confirmed that he had visited her

and their children on Christmas Eve. She told a *Plain Dealer* reporter that she left him three years ago because he had put her in the hospital a couple of times. They were married for nine years and divorced in September 1958.

When first asked, Hargrove consented to a lie detector test. Before the polygraph was administered, he was subjected to ten hours of relentless questioning with no sleep. At one point, he asked for a cigarette and a chance to think. After a few minutes, he said he would confess, but first he wanted assurance that Lois's children would not be taken away from her. Then, in a flat voice, he confessed to slaying Charles Clark. Evans, Hathy and Lake County assistant prosecutor John F. Clair were in the room to hear him.

Hargrove said he found a .22-caliber rifle in the basement of his apartment building. Sometime later, he bought a box of shells at a Willoughby hardware store, but he was not planning on shooting anyone at that point. Then, on the day of the murder, he suddenly decided what he was going to do.

Hargrove told police he drove to a street a block away from the Clarks' house and parked his car. By that time, it was dark. He walked through backyards until he got to the Clarks' house. He took up a position where he could see the kitchen window. He stood and waited for several minutes until Clark came into sight. He took aim and fired the rifle. Then he ran for his car.

From there, Hargrove claimed he drove to a deserted dead-end road in Mentor-on-the-Lake and threw the rifle into Lake Erie. Divers from Mentor-on-the-Lake and Cleveland police searched for the weapon, but after an entire day of hunting, they came up empty-handed. If the gun had been thrown into the water at that point, drivers would have found it within an hour, the captain of the dive team said. He added that the lake had been calm for several days, so it was unlikely the gun could have washed up on shore somewhere else or been taken out to deeper water.

While police sought to tie up loose ends with Hargrove's confession, Ostrander was uncomfortable with it. There were three points that did not jibe with the evidence. First, Hargrove described standing on Clark's patio forty feet from the house. The patio was only fifteen feet deep. Secondly, Clark's daughter was standing in the window beside her father, but Hargrove said she was not there. Ostrander's third point was that Hargrove was not sure whether the gun he used was an automatic or bolt-action. He finally claimed it was bolt-action. The prosecutor again asked Hargrove about a polygraph. This time the suspect declined, saying he had already confessed.

The bullet retrieved from Charles Clark's head was in two pieces, flattened to the point that ballistics experts had only two markings to make a match, even if they found the gun. Police were further

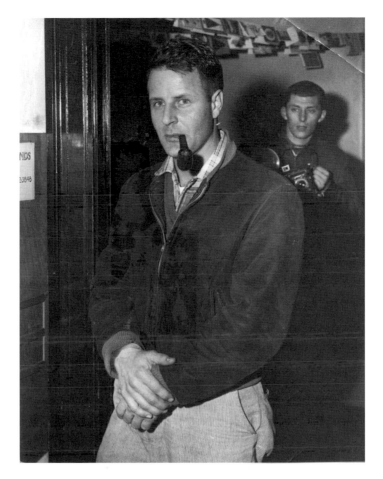

Floyd Hargrove was in love with Lois Clark. *Courtesy of the Cleveland Public Library.*

stumped when they went door to door looking for someone who had seen Hargrove's car in the area on Christmas Eve. No one had.

Police turned to the scheduled polygraph tests for three of Lois's past lovers. The tests were administered by a Shaker Heights expert, Sergeant Ralph Schaar. The men were all cleared. Finally, Hargrove agreed to a polygraph. It cleared him as well. The police had to let him go.

At that point, Hargrove recanted his confession, saying to the sheriff and the *Plain Dealer* that he loved Lois Clark deeply and had confessed "to spare her and her family any further investigation and suffering." He told reporter Jerry Snook that Lois was such a wonderful, beautiful person. He knew no one would understand why he went so far to protect and spare the woman he loved.

Hargrove said he was afraid Lois's life would be ruined if she were questioned in depth about their affair. "I figured I'd get about seven years in jail." He thought she would move to Columbus with the children so she could visit him. "Then when I got out we'd marry and begin a new life together."

Services for Charles Clark were held on Monday, December 28, at the Mentor Methodist Church, where he had been a congregant and Boy Scout troop leader. More than two hundred people attended. He was buried in the Mentor Cemetery.

One evening, Lois went in front of the WJW TV cameras asking for anyone who had any knowledge or information about the murder of her husband to come forward. She asked, "For my sake, for my children's sake and the neighbors' sake…" She broke down in the middle of it, and her mother-in-law had to finish for her.

"Instead of throwing dirt, why don't people think of the good she did?" Edith Clark asked.

Authorities thought they had the case wrapped up with their suspect's confession, but when the polygraph cleared him, it sent them in a new direction. Investigators decided to look deeper at Chuck's life and background. Ostrander said their picture of the slain man was of an upstanding citizen, a pillar of his church, a Boy Scout leader and a successful, up-and-coming businessman.

Chuck traveled a good deal for his company, and little was known about his business trips. Police wanted to know where he went and what hotels and motels he used. They wondered what he did in his spare time while on the road. Ostrander said they would widen their search for anyone who might benefit from Chuck's death or seek revenge for some reason.

In the meantime, the Shaker Heights polygraph examiner hooked up Lois Clark to the machine at the Painesville Courthouse. Investigators quizzed her for two and a half hours. When it was over, Ostrander said, "We are convinced that she knows nothing of the murder, nor did she perpetrate or collaborate in any way in arranging her husband's death."

After enduring the grueling questions, the widow, clad in a dark brown coat, walked out of the Lake County Jail, eyes straight ahead, head held high. She was accompanied by her father-in-law. "I'm mentally exhausted and extremely tired," she said.

The elder Clark told reporters that he and his wife were going to stand by Lois and hoped she and the children would go to Rochester to live with them. "We all make mistakes in our life and now she's paying for

hers," he said. "We're going to help her all we can. She's the same as a daughter to us."

Lois repeatedly told investigators she thought her husband's death was a freak accident. Emery E. Galloway at the Ohio State Bureau of Criminal Identification and Investigation in London, Ohio, said an accidental shooting was not possible. By examining the inside kitchen window and storm window and making tests at Clark's house and backyard, he determined the shot was fired on purpose. He thought the sniper steadied the rifle barrel in the crotch of a sycamore tree forty-two feet from the kitchen window.

Then Chief Hathy got a phone call from Hargrove's boss, Ozinga, at 8:30 a.m. on New Year's Day. He told the police chief that Hargrove had confided in him that he had purchased a gun in Chardon on December 23 and that he planned to kill Charles Clark the next day.

Police had already checked with twenty stores that sold guns in Lake County but got nowhere. Three stores sold guns in Chardon. With the help of the Geauga County sheriff, Hathy narrowed it down to the Carlson Hardware Store and called the owner at home. The storekeeper opened up for the police so they could go through his file on gun purchases. They found the purchase of a used Springfield, .22-caliber, single-shot, bolt-action rifle. The name printed on the file card was Robert G. MacClaren.

The gun cost eleven dollars, and the shells cost seventy-eight cents. The storekeeper said he did not connect the sale of the rifle with the murder or the photos of Hargrove in the papers.

Cleveland handwriting expert Joseph Tholl compared the printing on the gun file card with samples of Hargrove's on the cleaner's claim slips, as well as samples police collected while their man was in custody. Tholl determined they all had allegedly been printed by the same person.

"The phone call was the real break," Hathy said. He immediately got a warrant to arrest Hargrove for first-degree murder. Hathy figured Hargrove murdered Clark because he wanted to marry Lois. Bolstering his theory, Hathy found out his suspect had been an expert marksman in the Army Air Force during World War II.

Late on New Year's Day, police located and arrested Hargrove at his mother's in Toledo. That evening, he was flown by private plane back to Lake County, where, after several hours of questioning, he confessed for the second time. The next morning, he led police to a spot a few miles north of Chardon and showed them a utility pole with a slug dead center of a metal marker. Police pried the lead from the pole and sent it to the state Bureau of Criminal Identification and Investigation in London,

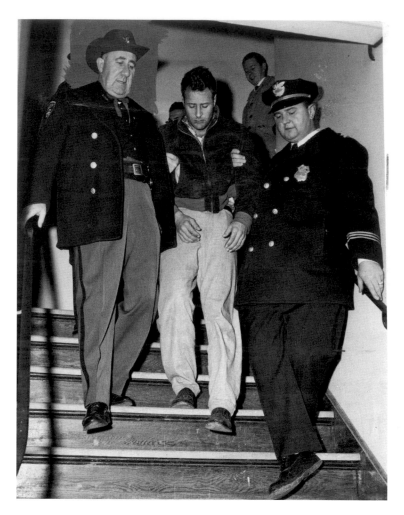

Left to right: Lake County sheriff William Evans, Floyd Hargrove and Mentor police chief Frank Hathy. *Courtesy of the Cleveland Public Library.*

Ohio. Galloway determined it was a match to the one taken from Clark's right temple.

While being questioned, Hargrove was sketchy on details of the shooting, but authorities figured if they could get their hands on the gun, they could neatly wrap up their case. Hargrove finally agreed to take them to the spot where he thought he disposed of the weapon. Instead, he led them in circles, and they were no closer to locating the gun.

In trying to explain why the lie detector had cleared Hargrove the first time he was in custody, Sheriff Evans said Hargrove was emotionally upset when

he took it. In fact, their suspected murderer had consulted a psychiatrist in the past because he had "personality problems." The polygraph works by showing changes in heart rate, breathing rate and perspiration, all indications of lying. Sergeant Schaar, an operator with ten years of experience, said it could not detect psychopathic liars.

Beverly Hargrove said her ex-husband had visited her and their children after his release from jail. It was a short visit, with him patting the five children on the head and then leaving. "He's what you'd call a street angel and a house devil," she told the papers. He seemed to always be searching for something, she said. He looked into different religions. One time, he

Floyd "Gene" Hargrove kept a picture of Lois and a Bible in his jail cell. *Courtesy of the Cleveland Public Library.*

espoused the medieval practice of Rosicrucianism, burning candles and incense behind locked doors. At a later date, he became a Jehovah's Witness. Most recently, he turned to the Willo Gospel Church, believing it was the true religion.

Psychiatrist Dr. Stanley F. Wallace, a friend and fellow congregant at the Willo Gospel Church, visited Hargrove in jail. The doctor suggested using sodium amytal to "help" the prisoner remember where he disposed of the gun. Hargrove took Wallace's suggestion and submitted to an injection of "truth serum."

Under the influence of the drug, Hargrove gave police a location in Kirkland Hills in the east branch of the Chagrin River. Mentor firemen searched for the .22-caliber rifle and came across it within twelve minutes. It was in two feet of water. The stock had broken off and washed downstream. A shell casing was still in the ejection chamber. The rifle was sent to the ballistics laboratory.

Prior to the sodium amytal, Hargrove said that he could not remember what he did with the gun. He said being under the influence of the "truth serum" caused him to accept the fact that he had murdered Chuck Clark. He said at the time he took the lie detector test, he had believed himself innocent.

"In my mind I had rejected reality that I had killed Clark," Hargrove told the *Plain Dealer*. "I just couldn't make myself believe that I had done such a thing." He said he was relieved that he had taken responsibility for the killing.

The after effects of the drug were still evident when Hargrove was taken before the judge for arraignment because he needed help to walk. He pleaded guilty. The guilty plea only served to waive the preliminary hearing, as Ohio law does not allow a formal guilty plea in a capital case. No bond was permitted.

In a 1963 case, *Townsend v. Sain*, the U.S. Supreme Court ruled that confessions obtained using one of the truth drugs were inadmissible in court. Like alcohol, sodium amytal or any of the truth serums diminish inhibitions, but they do not necessarily produce the "truth." It is possible to lie while under the influence of a truth serum.

A week after the arraignment, Hargrove hired intense thirty-seven-year-old Louis A. Turi Jr. of Wickliffe to defend him. Turi's first act was to get the preliminary hearing and Hargrove's guilty plea stricken from the court record. Turi said the plea and waiver of the preliminary hearing should have been given in writing instead of orally. He wanted the hearing and the plea wiped from the record so they could not be introduced against his client later on. Turi further criticized the prosecutor for taking

Hargrove before the court for an arraignment before the sodium amytal had completely worn off.

The trial began on May 16, 1960, in Judge Winfield E. Slocum's court. From the start, prosecutors John F. Clair Jr. and Edward R. Ostrander said they would seek the death penalty. Turi was assisted by thirty-two-year-old Painesville attorney Robert L. Simmons, who was mild in appearance but hard-hitting in court. Turi said he was confident of his client's innocence. "Don't be surprised at developments that come out at the trial," he told the papers.

Hargrove pleaded innocent and innocent by reason of insanity. He underwent forty-five days of psychiatric examinations at Lima State Hospital, and the hospital reported he was legally sane enough to face trial. The innocent by reason of insanity plea was withdrawn.

Newspapers from all over the state had been reporting on the murder and upcoming trial, so the courtroom was packed with spectators who wanted to hear every salacious detail in the case built on marital infidelity.

In his opening statement, Prosecutor Ostrander told the eleven-man, one-woman jury that "lust for another man's wife drove Floyd E. Hargrove to commit murder." He said the defendant and Lois Clark had been engaging in "secret trysts" for eight months and the shooting of Charles Clark was the "culmination" of their love affair. Then he laid out the alleged series of events and said he would show that Hargrove had admitted to the killing.

According to the *Lake County News Herald*, Turi told the jury that his client had nothing to do with the killing. He criticized the investigation and said of the police, "The type of inquisition they conducted, as you shall see, were a combination of Keystone Cops and Three Stooges comedy."

Turi said if the affair between Lois Clark and Floyd "Gene" Hargrove established a motive, there were other people who would have had the same motive. "But it may very well be that Mrs. Clark was the intended victim and not her husband." He said there was no evidence that the killing bullet was intended for Charles Clark.

The jury was taken to the Clark home and given a view of the spot from which police alleged Hargrove took aim at Charles Clark. Then they went to John Ozinga Jr.'s home. The jury visited Robert Diday's home, which the defendant also visited on Christmas Eve. Next, the jury got a look at the utility pole that Hargrove allegedly used for a practice shot. Lastly, the jury viewed the spot where the alleged murder weapon was found.

On the day Lois Clark took the stand, she was wearing a severe looking navy blue suit. The courtroom got very quiet as she recounted her intimacies with the

Lois Clark had many affairs. *Courtesy of the Cleveland Public Library.*

handsome defendant. She admitted that she and her lover had met several times a week, mostly at her home, while her husband was at work. She said she visited "Gene's apartment in Painesville at least eight times." The couple often met for coffee at a restaurant in the Willo Plaza.

"Were you in love with Hargrove?" the prosecutor asked.

"Yes, I was," she said. She kept her eyes on the floor and never looked at her former lover.

She told the court they decided to stop seeing each other in November. "I was under a strain and I thought it would be better if he met someone else." They did see each other on Christmas Eve morning.

The reporter for the *News Herald* observed that as Lois Clark testified, she either twisted her handkerchief in her hands or gripped the arms of the witness chair.

Defense attorney Simmons asked her about other infidelities. She told of three other men with whom she had been intimate. She admitted to a three-month fling with a Willoughby police lieutenant, who denied ever being Lois Clark's lover. She broke it off with him because of Hargrove. The police lieutenant told her he did not play second fiddle to anyone. When his name came out in court, the mayor of Willoughby suspended him without pay. He later resigned from the police department. Another lover was a car salesman, who followed her in his car and made calls to her after she broke off their relationship to be with Hargrove. The third was a hairdresser, and she also broke off with him when she started seeing Hargrove.

Simmons asked her if she would believe Hargrove if he swore under oath that he did not kill her husband. She said yes.

Prosecutors suffered a setback when the clerk at the Carlson Hardware Store where the alleged murder weapon was sold could not identify it or Hargrove as the buyer in court. The gun was sold two days before Christmas, when at least four hundred people had shopped in the store, and the clerk could not remember the defendant. Shown the rifle, he said it was the same type he sold that day, but he had not recorded the serial number on the card, so he could not be sure.

The Mentor fireman who retrieved a .22-caliber rifle from the Chagrin River was called to the stand. Assistant Prosecutor Clair showed him the gun and asked if it was the same one he found. The fireman said, "It looks like it. But I couldn't say for sure."

The policeman who recovered the slug from the utility pole by using a chisel was next to testify. Under cross-examination, he was forced to admit that he had put a nick in the bullet when he dug it out.

Handwriting expert Joseph Tholl testified that in comparing the printed name—Robert G. MacClaren—on the Carlson Hardware Store gun-purchase card with Hargrove's printing on the claim slips from Moss Point Cleaners, he could tell they were printed by the same person. Turi brought out that police had Hargrove copy the printed name on the file card over and over until the printing was close.

Simmons asked Tholl whether he had ever made a mistake. Tholl said that as an expert, he had examined handwriting samples for more than 2,500 cases and not made a mistake.

Simmons took issue with that statement. "Well, Mr. Tholl, you have made a serious mistake today." The attorney pointed out an erasure mark near the G on the gun-purchase card. Tholl previously said the mark was from "pencil failure." Simmons asked Tholl to look at the mark more closely. "Yes, I can see it now."

Mentor chief Hathy testified that Hargrove had admitted to using the name Robert G. MacClaren to buy the rifle on December 23 and had given the location of where he test-fired the gun. According to Hathy, the test bullet hit a metal tag, three-quarters of an inch by two inches, square in the center.

While testifying about the bullets, Hathy accidently dropped the slug taken from Clark's skull. It bounced on the floor and rolled under the witness's chair. Both Ostrander and the chief dove for the bullet. When it was safely back in Hathy's hand, Clair asked, "Now that I have my breath back, can you identify it?"

Hathy said it was the bullet Coroner Richard W. McBurney handed to him the night of the murder, and it had been in a safe at the village hall until he turned it over to the ballistics expert at the Bureau of Criminal Identification and Investigation. More closely questioned by the defense, Hathy conceded he had forgotten to mark the slug for identification until five days after the coroner removed it from Clark's right temple, compromising the chain of evidence.

Prosecutor Clair questioned Hathy about Hargrove and Lois Clark's sexual relations. He said Hargrove admitted to him that the relations were "abnormal." Turi objected and called for a consultation before Hathy could go on. During the break, Hargrove told the press he never told Hathy anything about his intimacies with Lois, but he had talked about them with Sheriff Evans, McBurney and Clair.

"That's why I confessed the first time," he told the reporters. "They told me that if I didn't they'd bring out our whole sex life at trial."

The prosecution wanted to have Chief Hathy and Sheriff Evans testify that Hargrove allegedly had told them while under sodium amytal where the rifle was. Turi previously said the defense would fight any talk of a confession under a truth serum. He said the confession was "illegally and fraudulently obtained." When it was brought up again, he objected, and after another conference, Judge Slocum sustained the objection.

On the ninth day of the trial, prosecutors, defense attorneys and Judge Slocum had a three-hour conference in chambers. This time, Ostrander and Clair wanted to introduce a January 2 tape recording of Hargrove admitting to the murder. Turi and Simmons tried to keep the jury from hearing the

tape, calling the confession "involuntary" and "given under duress." The state won. Turi told reporters later on that the defendant was in no shape to be talking on tape at the time. His voice was groggy and investigators were haranguing him, he said. "In his condition, he would have confessed to anything."

The questioners were Evans, Hathy, McBurney and Clair. On the tape, Hargrove admitted to buying the rifle under the assumed name of Robert G. MacClaren and firing the test shot. The questioning was aggressive. Finally, the defendant said, "I told you I did it. I'll confess to killing him, but I don't know where the gun is."

Evans hammered away at him. "Get it off your chest and quit fooling around." At one point, Evans said, "Think of Lois. Think of the kids. Do you want me to tell the newspapers about your abnormal relations with her?" Again he demanded to know where the gun was. "Let's get this gun and get it over with. Let's stop this sordid mess."

The recording also revealed Evans's threatening to charge a doctor who treated Lois for a miscarriage.

Defense Attorney Simmons questioned Evans until the law enforcement officer admitted he had threatened Hargrove with spreading "all the dirt about him and Lois to the newspapers." The sheriff even admitted he had promised Hargrove he would keep quiet about his intimacies with Lois.

Ballistics expert Galloway and Steve Molnar Jr. came to the stand to back the prosecution's contention that the bullet that killed Clark and the slug Hargrove allegedly shot into the utility pole were shot from the same gun. Both experts testified that the markings on those bullets matched up to the lands and grooves on the inside of the barrel of the .22-caliber rifle pulled from the Chagrin River. Grooves are cut in a spiral lengthwise down the barrel. Lands are raised areas between the grooves. Lands and grooves are sometimes referred to as rifling.

Turi pointed out to the experts that the killing bullet was so mutilated that positive conclusions could not be reached. There was only one land and groove on that bullet, compared to six on the utility pole bullet. But Galloway and Molnar held to their conclusions.

When it was time for the defense to present its case, Turi countered Galloway's and Molnar's testimonies by calling his own expert, David L. Cowles, founder and retired chief of the Cleveland Police Department's Scientific Unit. Cowles had been involved in the Sam Shepherd case.

Judge Slocum allowed the defense time for Cowles to do his own ballistics tests in London with the same equipment Galloway had used. His tests

showed that neither bullet came from the .22-caliber rifle that prosecutors and police claimed was the murder weapon.

Cowles went to Clark's home for a firsthand look at the surroundings. The retired policeman inspected the rear of the property, where he found evidence of a target range next to the lot line and adjacent to a vacant field. A boulder approximately one foot high by one foot wide stuck out of the ground with broken glass from bottles lying in the grass around it. Cowles also noticed a piece of wood tacked to a nearby tree. A hole in the wood was the size of a .22-caliber cartridge case.

Cowles examined the sycamore tree at the rear of the house. The crotch of the tree where the rifleman had allegedly rested the barrel of the gun during the fatal shot was four and a half feet off the ground. To Cowles's way of thinking, a man Hargrove's size—six feet tall—would have had difficulty firing from the angle if he were standing. "From such a stooped position, I don't think he could have hit much of anything." If he were kneeling, the trajectory of the bullet would have been much higher and struck above the window, he said.

Supported by Cowles's investigation and testimony, Defense Attorney Turi argued that it was entirely possible that the fatal shot was a tragic accident that happened while someone was doing target practice. Asked by a *News Herald* reporter how someone could target practice in the dark, Turi said the shooter may have used the lighted kitchen window as a frame for the tree.

Near the close of the trial, Floyd Hargrove took the stand. The court was standing-room only, 70 percent of the spectators being women. Not a whisper could be heard. Clad in a gray suit, the attractive Hargrove was calm but adamant that he had been bullied and coerced into a confession. "I was tired of hearing them scream at me, so I confessed." He said he had not murdered Chuck Clark, but he confessed to get the sheriff and chief "off my back." He also confessed because Evans told him to confess or else Lois and her children would be finished in Lake County.

Simmons asked him what police intended to bring out about Lois. Hargrove became obviously distressed and took a moment to gather himself before answering. In a low voice, he said, "They were referring to a mutual exchange between two people who loved each other sincerely." They had made it seem "cheap and dirty," he said.

Police had questioned him from 10:00 p.m. on Christmas Eve until he finally made a confession on the afternoon of December 26. During that period, he had only fifteen minutes of sleep. He said the threats and the lack of rest finally broke him down.

Hargrove told the jury he first met Lois Clark at a company dance in 1956. Three years later, he met her again at the shopping mall, and she invited him to her and her husband's home. A few weeks after that, he saw her at a restaurant, and she extended the invitation again. The affair began when he visited their home on St. Patrick's Day and Chuck was not at home. They saw each other frequently after that.

In November, she told him she was pregnant. He thought it was probably his child, so they went together to a doctor, who gave Lois a prescription. A week later, she had a miscarriage. At that time, the two lovers decided it was better for everyone to end their affair.

Hargrove gave the jury the same detailed account he gave the police of his whereabouts on the night of the murder.

He said Ozinga's claim that he (Hargrove) wanted to kill Clark was based on a dream Ozinga had. He stressed he had never mentioned a gun to Ozinga.

As far as the bullet in the utility pole was concerned, Hargrove had often driven past it and seen children using it for target practice. He pointed the pole out to police because he knew they would find a bullet in the marker.

Turi told the newspapers that the police never investigated the possibility of a freak accident from someone target shooting. Instead, investigators "concluded Floyd Hargrove was a likely suspect and have thrown the full force of their efforts toward his conviction."

During his closing argument, Ostrander went back over the state's evidence, painting a picture of Hargrove as "a heartless killer, who, on Christmas Eve, murdered Clark before the eyes of his wife and children."

Clair told the jury Hargrove had no scruples. He reminded the jury that Hargrove was an adulterer, a wife beater and a reader of girlie magazines. He told the jury that Hargrove had admitted to assisting in an abortion, and he failed to pay alimony to his ex-wife. Clair ended by saying there was just one man who could have committed the murder: Floyd "Gene" Hargrove. "The state of Ohio is not seeking revenge but justice."

In Turi's closing statement, he said the defendant was not on trial for adultery or wife beating. He recalled for the jury the other men Lois Clark had had affairs with and said they would have the same motive for murder.

He called the police inept. "They were obsessed with the sex angle, and they grabbed him and assumed he committed the murder."

"Strip the sex away from the case and what have you got?" Simmons asked.

There was no compelling evidence that Clark was even murdered, the defense said to the jury. Most likely, the victim was killed by a stray bullet from a careless shooter during target practice.

In less than five hours, the jury returned with a "not guilty" verdict. When the verdict was read, the jammed courtroom erupted in cheers.

The foreman said that in the end, the state did not prove its case. Although they thought it was possible Hargrove could have killed Clark, none of them was convinced beyond a reasonable doubt that he did. In particular, they put more weight on Cowles's ballistics testimony than on the state experts.

Lois Clark was at home when the verdict came in. "The newspapers and everyone else had him convicted long ago," she said. "It was not in him to have done such a thing."

At first, Hargrove hoped for a future with Lois, but they never met to discuss it.

Lois collected $105,298 in life insurance, packed her four children into a new station wagon and drove to California. In December 1960, she married a Fresno attorney, David E. Smith.

In December 1960, Floyd Hargrove filed a $950,000 lawsuit against Sheriff Evans, Chief Hathy and Coroner McBurney, charging false arrest. The suit was dismissed because the defendants were improperly served. The court ruled that only a disinterested party could serve summonses. McBurney and Evans served each other.

Hargrove remarried and lived with his wife, Betty, in Cincinnati, where he worked as a salesman. He died of a heart attack in April 1978.

Sheriff Evans said as far as he was concerned, the case was closed. "We had the man who did it."

Prosecutor Ostrander was shocked at the verdict and said the Clark murder file would be closed, marked unsolved.

10

WHATEVER HAPPENED TO ANITA?

Pretty Anita Kay Drake turned fifteen years old on Monday, October 14, 1963. After school the next day, she left her home on Victory Avenue in Louisville, near Canton, to go to the Campion Dairy. She was never seen again.

A freshman at Louisville High School, she enjoyed school and got good grades, said her older sister Linda Boyd. She was the seventh child in a family of twelve. She had three sisters and eight brothers. Her father, Kermit Sr., supported his wife, Virginia, and their children as a factory worker at Union Metal.

Twelve children must have made a lot of work for Virginia, but Roger Drake, a brother who was twelve at the time of Anita's disappearance, said, "Everyone pitched in." They were a large but happy family. "We would do things together. Dad would take us fishing, or we'd go berry picking." They had a large garden and canned some of their harvest. Growing up in the '50s and '60s, the kids listened to the radio and played records for entertainment, Roger added.

At the time of Anita's disappearance, there were six children, counting Anita, still living in the ranch-style, three-bedroom, one-bath house. A now deceased older brother, Gary, and his wife lived in a small house on the back of the property. It was a nice neighborhood to raise children with plenty of outdoor space to play.

At 4:30 p.m. on Tuesday, October 15, Anita told her mother where she was going. The temperature was starting to dip from its high of sixty

Anita Drake disappeared in 1963. *Courtesy of Roger Drake.*

degrees, so Anita put a black coat on over her white-hooded sweater and gray skirt. She slipped into her beige flats and left the house for the half-mile walk to the Campion Dairy, a little mom and pop soda fountain owned by Bill Campion and run by Mama T. The shop sat on the north side of Mahoning Road, between Louisville and Canton, and was a favorite hangout for neighborhood teenagers.

As it grew dark that night, Kermit Sr. and Virginia began to worry. They went to look for Anita but couldn't find her or anyone who had seen her. Finally, around 11:00 p.m., when she had not turned up, they called the

Stark County Sheriff's Office. Sergeant G. Reese took the initial missing persons report. He wrote her description: "She was five feet, four inches tall and had a slim build of only one-hundred ten pounds. Her hair was light brown and her eyes were brown. She had no identifying scars." A later description on the Charley Project website page added that she had a mole an inch below her lower lip.

At first, the family feared she had run away. Her parents did not know of a steady boyfriend, but the initial police report stated that she may have been in the company of a certain young man, and their destination could have been Kentucky. The young man in question was a neighbor on the next street over from the Drakes' house. He drove a semi-truck and made many runs to Kentucky.

"He hung around our family. My brothers mostly." Roger also said the young man often did drugs. "He was like a loner. He was not a desirable person. He was in and out of jail for small stuff. I thought of him as a predator."

Kermit Sr. never liked this young man because he rode a motorcycle, was unkempt and had long hair and a beard at a time when long hair on men was not fashionable. He was divorced with three children, and Kermit Sr. did not think he was a good father.

But would Anita have taken off with this man? Would she have run away from home? If she had, she had not taken any clothing with her. If she had any money, it was just pocket change. It is not known whether the police ever questioned the young man. The police file is only two pages, and the newspapers never covered her disappearance.

Anita may have been a bit rebellious, but no more so than most teens. Her brother Roger remembers she tried to boss him and the younger boys around. But what teenage girl wants to be pestered by her little brothers?

Roger and his brothers did not pay much attention to her that summer before she disappeared. As young boys, they were busy playing outside most of the time. Anita spent most of that summer at Linda's house.

"She was smart, and she was a great artist," Linda said. "She had a wonderful personality." Linda, who was married at the time, probably knew Anita best. Anita babysat for Linda's four-year-old son, taught him his alphabet and how to read. When it was time for him to start school, he was more than ready because Anita had spent time with him.

"She had a great sense of humor." Linda told about the Christmas her husband wanted new living room furniture. "Anita went and bought a small plastic doll house–size living room set and wrapped it up and gave it to him as a present. It was funny."

Although Anita did not seem to be interested in any one particular boy, Linda did remember an incident sometime prior to her sister's disappearance. Anita was babysitting at Linda's when the phone rang. It was the wrong number, but there was a young man on the other end. They talked for awhile. He told her his name was Eddie and he worked and traveled with a hypnotist from California. Anita told her family about him and said she was going to meet him. Her family did not know whether she ever did meet him, but they told the police about the incident.

Another younger brother, Kermit "Junior," was only four when Anita disappeared, but he remembers her. He has had a lot of years to think about what could have happened to her. He wonders if she met friends that night and got in a car. "What may have started out to be fun, maybe went wrong, terribly wrong," he said. "Anybody involved is probably not around to tell anymore."

There were sightings through the years. Not too long after Anita disappeared, Gary was at the Holiday Bowl on Mahoning Road. He thought he saw her coming into the bowling alley. When she saw him, she turned and immediately left. He was sure it was her. He chased after her on foot but lost sight of her. Could it have been Anita? Or was her brother just hopeful?

Two years after she disappeared, another sister, Cheryl Lee, also now deceased, received a tip that Anita was working at a JCPenney's in Columbus. The information came from a person who supposedly hired her. The person identified Anita from a photograph as someone named Nancy Woods. The Stark County sheriff's report of investigation form said, "Anita Drake was known to have told of having ficticious [sic] friends by the name of Ann Billings and Nancy Woods." The description fit, especially the mole on her lip.

The Stark County sheriff's investigator sent word to the Columbus juvenile bureau, but the family decided to conduct its own investigation. They went to the JCPenney's store to see for themselves. It was a dead end. They did not find Anita or anyone named Nancy Woods. If there was a Columbus police report, it was unavailable.

Kermit Sr. and Virginia saw a picture of a woman on television who had been arrested in Cleveland. It looked enough like Anita that they and Linda drove up to the jail to have a look for themselves. They looked through the bars at the woman, but it was not the missing Anita.

"We'd get out hopes up," Junior said. "Every lead we ever had ended in a dead end."

And there were phone calls. Every Christmas Day around 6:00 p.m. for five years after Anita went missing, someone called Virginia. "The phone

would ring. When answered, no one would say a word." Linda said. "Mom always thought it was Anita, and she wanted to hear Mom's voice."

Roger did not think so. He thought it was someone who had killed his sister and was trying to make the family believe she was still alive. "I think someone murdered her."

Junior thinks her body could have been dumped somewhere, perhaps in a lake on a piece of uninhabited, wooded land not far from Anita's home. "Maybe she's living somewhere under an assumed name," Junior said. "Maybe she has children. Maybe something happened and she was ashamed to come home." But he does not believe this is the case. "If someone did something to her or knows something, they probably took it to their grave," he said with resignation.

According to an October 2013 *Canton Repository* article written by Lori Monsewicz, the four surviving Drake siblings cooperated with lab technicians from Fort Worth, Texas, by giving saliva samples for a DNA comparison to a woman's body found in Delaware. There was no match, but the samples went into CODIS, the FBI's Combined DNA Index System, and the National Missing and Unidentified Persons System Database, known as NamUs.

Roger was always suspicious of the young man who hung around the family, the one their father did not like. In the 1990s, that man succumbed to throat cancer. Before the man died, Roger asked him if he had anything to do with Anita's disappearance. Disease had wasted away the man's voice, but he wrote "No" on a piece of paper.

Anita's father, Kermit Drake Sr., died on February 14, 2003. Her mother, Virginia, died on May 16, 2007. They died without ever knowing what happened to their pretty, vivacious daughter Anita. "It really affected them the longest day," Roger said. "They really mourned."

Will this family ever find out what happened to their sister? "Everything is just a guessing game," Junior Drake said. "We just don't know."

SOURCES

Newspapers

Akron (OH) Beacon Journal
Akron (OH) Press
Ashtabula (Ohio) Gazette
Ashtabula (Ohio) Star Beacon
Canton (OH) Repository
Chicago Tribune
Cincinnati Commercial Tribune
Cincinnati Post
Cleveland (OH) Leader
Cleveland (OH) Plain Dealer
Columbus (OH) Dispatch
East Liverpool (OH) Review
Geneva (Ohio) Times
Lake County (OH) New Herald
Lima (OH) News
Newark (OH) Advocate
Orrville (OH) Courier-Crescent

COURT RECORDS, CENSUS AND AUTOPSIES

Hargrove v. Evans, et al. Docket, n.c., Lake County Common Pleas Ct. (1960).

"Ohio, County Death Records, 1840–2001." Index and images. https://familysearch.org.

"Ohio, Marriages, 1800–1958." Index. https://familysearch.org.

Smith, Stephen, M.D. *Report of an Examination of the Alledged* [sic] *Skull of the Late Mr. Collins, of Cleveland, Ohio. With Conclusions.* New York, 1878.

State of Ohio v. Hargrove. Docket, case no. 4931, Lake County Common Pleas Ct. (1960).

Summit County Medical Examiner. Coroner's inquest (Case No. 4324). Akron, OH: 1929.

Townsend v. Sain. 372 U.S. 293. (1963).

United States census, 1860, 1930.

BOOKS AND MAGAZINES

Beaufait, Howard. "The Case of William Potter, 1931." *Cleveland Murders.* New York: Duell, Sloan & Pearce Inc., 1947.

Corts, Thomas E. *Bliss and Tragedy: The Ashtabula Railway-bridge Accident of 1876 and the Loss of P.P. Bliss.* Birmingham, AL: Sherman Oak Books, 2003.

Leeke, Jim. "Who Killed Harry Beasley? The Unsolved Murder of Newark's Hero Cop." *Timeline Magazine* (October/December 2004): 44–53.

Peet, Reverend Stephen A. *The Ashtabula Disaster.* Chicago: Lloyd & Co., 1877.

Simmons, David A. "Fall From Grace: Amasa Stone and the Ashtabula Bridge Collapse." *Timeline Magazine* (June/July 1989): 34–43.

Waight, Glenn H. "Carnival Girl." East Liverpool Historical Society, 2007.

Websites

EmedicineHealth. "Drowning Causes, Symptoms, Treatment—Dry Drowning vs. Wet Drowning." http://www.emedicinehealth.com/drowning/page3_em.htm.

Wikipedia. "United States Occupation of Veracruz." https://en.wikipedia.org/wiki/United_States_occupation_of_Veracruz.

INDEX

ABOUT THE AUTHOR

Jane Ann Turzillo is a full-time author and speaker. She concentrates on true crime and history. *Unsolved Murders and Disappearances in Northeast Ohio* is her sixth book for The History Press and Arcadia Publishing Company. She holds degrees in mass-media communication and criminal justice technology from The University of Akron. She is a member of Mystery Writers of America, Sisters in Crime and the National Federation of Press Women.

youth soccer

drills

age **7** to **11**

Also available from A & C Black

101 Youth Soccer Drills – 2nd edition
Age 12 to 16
Malcolm Cook

Soccer Training – 7th Edition
Games, Drills and Fitness Practices
Malcolm Cook and Jimmy Shoulder

Soccer Coaching and Team Management
2nd Edition
Malcolm Cook

The Soccer Goalkeeping Handbook – 2nd edition
The essential guide for players and coaches
Alex Welsh

malcolm cook

youth soccer

drills

age **7** to **11**

SECOND EDITION

Published by A & C Black Publishers Ltd
37 Soho Square, London W1D 3QZ
www.acblack.com

Second edition 2004
First edition 1999
Reprinted 2001, 2003

ISBN 0 7136 6456 8

A CIP catalogue record for this book is available from the British Library.

Acknowledgements
Cover photograph © Getty Images.
Textual photographs © EMPICS.
Illustrations on pages 11–13 by Jean Ashley.
All other illustrations by Malcolm Cook.

A & C Black uses paper produced with elemental chlorine-free pulp, harvested from managed sustainable forests.

Typeset in 10 on 12pt DIN Regular
Printed and bound in Great Britain by The Cromwell Press, Trowbridge, Wiltshire.

CONTENTS

ACKNOWLEDGEMENTS

I would like to thank Les Kershaw (Youth Academy Director, Manchester United Football Club), who was instrumental in the development of the club's excellent youth scheme, for endorsing this book with his foreword. I would also like to thank Nasser Navsarka and Wayne Scott for their help with design work and photocopying, and Forsport International for their excellent training equipment. Finally, best wishes to all the coaches who work with young players, wherever you are – your work makes a difference and is vitally important to the future of our great game – good coaching!

FOREWORD

Malcolm Cook's third book for the soccer market is timely with the advent of the Football Association Academies for the coaching and development of young soccer players. Very little literature on soccer has been dedicated to primary school children, who have tremendous enthusiasm and a capacity to learn new skills.

Anyone involved in developing young soccer players, from primary schools, junior clubs, Centres of Excellence through to Academies, will find this book useful. It gives a logical series of practices in all the basic techniques, without the need for specialised or expensive equipment. The practices are simple, but effective, and cater for all abilities. David Beckham, for example, gained exceptional skills in soccer by practising these kinds of techniques when he was a young player. His free kicks, crosses, and long and short passes are now acclaimed worldwide.

In *Youth Soccer Drills* Malcolm has successfully brought together his vast experience as a soccer coach and teacher in an easy-to-follow and practical manual. I recommend this book to both experienced and prospective coaches, and anyone with an interest in developing young soccer players.

Les Kershaw
Youth Academy Director
Manchester United Football Club

INTRODUCTION

This book is designed to support the coach, teacher or parent, and aid them to obtain the best results from their practice sessions with young footballers. There are a number of books available on coaching methods and technical skill acquisition. However, the main aim of this book is to provide a comprehensive programme of varied, realistic and educationally sound drills for young players which will help them to improve progressively.

There is little attempt to tell the coach how to coach, for each one will employ his or her own unique style and characteristics that will, naturally, affect the learning of young players. I have noticed that some books containing drills are impractical and not designed for the particular age groups that are supposed to be using them. In this book I have attempted to provide the coach with a supply of practical and functional drills in a simple format which takes into account the growing needs of youngsters between the ages of 7 and 11 years. Young players at this stage are curious, enthusiastic and constantly on the go. They learn to become more co-ordinated over time, and the wise coach will allow them to experiment and play down the competitive element – they need plenty of variety as they learn new skills.

The players will learn to improve their skills, have fun and develop good social habits through the constant use of the drills. The role of the coach, teacher or parent is to provide the support, guidance and encouragement for young players to maximise their potential. I hope this book achieves what it sets out to do, and becomes a tried-and-tested tool kit of practical resource material for the coach in the years ahead.

It should be emphasised at the beginning that although we use the word 'he' throughout the book, this is only for convenience. It does, of course, also refer to female players, who also give so much to the sport and are developing all the time in their own right.

Rivaldo, the Inter Milan and Brazil midfielder, is a seriously skilful performer. Like all great players, he has practised his skills over many years so that he can produce them automatically. Young players must realise that there is no short cut to success; just like Rivaldo, they need to continually practise their skills over and over again! (Photo: Nigel French)

PRACTICE ORGANISATION

The good coach will endeavour to produce an effective learning environment for his players that promotes safety, fun and purpose and ensures progression. He should plan each session beforehand and decide on the skills or topics that he wishes to help his players learn. He should select the combinations of drills from the book and arrive early at practice in order to set up and prepare equipment for the players. Good organisation generally makes for good coaching and motivation. Here are some basic guidelines for the coach to consider when using drills from the book.

practice service

The coach will have to demonstrate, and allow his players to practise ways of serving the ball to their team-mates. Some of the techniques will be familiar to them while some will be relatively new – however, all of them will be valuable to their learning. The majority of service actions are by hand as this tends to guarantee accuracy. However, as soon as the player can consistently kick the ball well then he can serve in this manner too.

These are the service techniques:

Underarm
The player places both hands under the ball, between her knees with legs bent. She tosses her arms and hands outwards towards the target, releasing the ball while straightening the legs to add momentum to her movements.

Throw-in The player places both hands around the back of the ball, which rests on the back of his neck. With one leg in front of the other to give himself a more balanced position, he bends his upper body backwards before swinging forwards in a smooth motion to thrust the arms forwards together and send the ball on its way.

Javelin The player balances the ball using one hand and wrist to secure it. The body is turned side-on with the other arm aiming towards the intended target. The player then whips his arm over and through to hurl the ball high and far.

Bowling (*see* top of page 13) The player holds the ball from below and crouches on one knee, swinging his arm backwards with the ball before swinging through to roll the ball along the ground.

Kicking Conventional techniques such as the push-pass (*see* figure middle left), using the inside part of the foot, is adequate for short-range services, while the instep-pass (*see* figure middle right) can be used to kick longer distances. If the service needs to be delivered higher, for example to give a player heading practice, then the player serving the ball can gently toss it up to himself before playing a volley-pass (*see* bottom figures).

Many of the drills require one of the players to serve the ball to a team-mate to allow him the opportunity to practise and develop his skills. As such, the delivery of the ball needs to be accurate, sensitive and realistic, whether the aim of the drill is to work on controlling, shooting or heading the ball. Remember the maxim: '**poor service starves the practice**'.

footballs

Many of the drills do not require a lot of balls. However, where possible, the quality should be the best available, with particular attention paid to their size and weight. For example, when introducing heading to young players, make sure it is a 'pleasure not a pain' for them to practise by using a light ball. I find volleyballs are perfect at this stage until the players build up the necessary confidence and technique and can move on to the conventional football. It is a good policy for the coach to have a variety of balls of different sizes, colours, markings, weights and textures. He can then change them depending on the ages of the players, the skills being practised or the difficulty of the drill. Players will progress more quickly, develop greater sensitivity and 'touch' for the ball and generally be more motivated to practise with a variety of balls.

equipment

Self-discipline is part of being a good footballer. Build this quality in your players by getting them into the habit of assisting the coach to set up and take away equipment used in the practice session. Young players like to see an attractive learning environment where portable goals, coloured bibs and cones, varied balls and flag poles are safely set up – it's all part of the fun!

space

The distances and areas mentioned in the book are only approximate. The coach needs to observe how much space and time players require to make the practice drill effective. He should then modify it by having the players stand nearer or farther from each other, or enlarging or reducing the area they are working in. The space will depend on the players' sizes, maturity, ages and skill levels – don't be afraid to change distances when necessary.

The diagram on page 15, which shows one half of a junior-sized football field, could be utilised by using the flank areas A and B for crossing or long-kicking, while C could be used for goalkeeping, shooting or heading. Areas D and E could be used for small-sided games. The centre circle area F could be used for various skills or tactics.

The enterprising coach can also use cones on the ground to devise varied shapes such as squares, rectangles, circles and triangles for coaching purposes.

Another effective coaching aid is a wall. Indoor or outdoor, players can use garage doors, house walls or even boards. This is safer with a light sponge ball – no broken windows! The rebound surface can allow the player to attain many repetitions of practice in a short time.

numbers

Ensure that the number of players in each drill is relatively small so that every player has repeated opportunities to practise the skill and improve his ball control. There is nothing worse than having long files of bored youngsters awaiting their turn to perform skills – keep them active! However, the other extreme is for young players to work non-stop and become physically and mentally exhausted. The good coach will intersperse the more physically demanding drills with the lighter ones, in order to allow young players to work at their maximum without becoming overtired.

The drills can be used in a progressive way, working from the easiest to the more difficult. Alternatively, varied skills and drills can be used when the coach thinks fit. However, the same drill should not be used for too long as this can cause boredom. On the whole, youngsters have a shorter attention span than adults, so they do not like 'overcoaching' – it is best to repeat drills often but to keep them short.

Patrick Vieira, the Arsenal and France midfield dynamo, is a powerful player who stamps his influence on his team. Tall, elegant and oozing skill, like all great players he realises the importance of warming up correctly prior to practice or the competition match. (Photo: Neal Simpson)

WARMING UP

The coach needs to ensure that the players prepare themselves correctly – physically and mentally – before they commence practice. There are three main reasons why players should warm up.

1 To mobilise the joints of the body, increase blood flow, raise muscle temperature and stretch the muscles. This will allow the players to move through a greater range of movement and will help prevent injury.

2 To maximise performance. The body performs better when demand on the circulatory and respiratory systems increases gradually. Demanding physical activity will fatigue the body prematurely if the body is not warmed up.

3 To prepare mentally. The mind needs to 'tune-in' to the practice situation so, by rehearsing movement patterns from the game, the mind becomes activated and focused on the skills that are needed for practice.

The effective warm up consists of three phases:

Phase 1 The first phase focuses on getting the whole body mobilised gradually. Light running activities are used to raise the body temperature and heart rate.

Phase 2 The second phase involves stretching the major muscles of the body and the joints. Particular attention should be paid to the specific muscles and joints that are used in playing the game, i.e. the spine, hips, and legs.

Phase 3 The third, and final, phase is the most intensive and involves activities performed at a faster tempo that allow players to practise and rehearse patterns of movements from the games. Note: players should do some light running after the stretches in phase 2 to raise the heart rate and temperature before starting this phase.

By the end of these three phases the players will be ready mentally and physically to get the best from the practice drills. Most coaches have enough material to carry out phases 1 and 2 competently, so the drills provided in this chapter are specifically designed for phase 3 of the warm-up.

Purpose: Sidestepping an opponent

Practice set-up: Two files of players stand facing each other 12 yds apart with a cone placed in the centre. The first player from each file runs towards the other until they are 2–3 yds away. At this point they both dummy to go one way before changing direction and passing each other on the other side of the cone. The coach informs them which direction they should all take as they pass their partners. They then join the back of the other file and await their next turn.

Equipment: Five cones

Progressions: Players should practise dummying to both sides. As they progress, the tempo of the drill can be increased.

drill 2

Purpose: Marking and dodging movements

Practice set-up: Two files of players stand facing each other 12–15 yds apart and the players from each file work in pairs. The first player runs forwards towards the other side with his partner 'shadowing' him 1–2 yds behind. The leading player changes direction often, with his partner attempting to follow his every movement as closely as possible. As soon as they arrive at the other side, the next two players repeat the drill in the opposite direction. Each pair should alternate each time between being a 'leader' and 'shadower'.

Equipment: Four cones

Progressions: Start slowly and increase the pace as players improve.

Purpose: Changing direction and pace

Practice set-up: Two files of players face each other 12–15 yds apart in a channel 10 yds wide. The first player from one file runs across the area and tries to get across the far line to join the opposite file without the opposing player tagging him. Both players run towards each other and alternately attempt to evade, if they are an attacker, or close down, if they are a defender, their opponent. When they finish they join the file opposite and the next two players emerge.

Equipment: Four cones, one set of coloured bibs

Progressions: Make the channel narrower for the attacker or wider for the defender so that they have to be more agile in their running movements.

drill 4

Purpose: Changing direction at speed

Practice set-up: Two files of players face each other 16–20 yds apart with a slalom of flag poles placed 1–2 yds apart on the ground. The first player runs in and out of the poles, ensuring that he does not touch them until he reaches the other side, where the next player repeats the exercise in the opposite direction.

Equipment: Six to eight flag poles

Progressions: To progress, the tempo can be increased, the number of poles can be increased, or the space between them narrowed to make it more difficult for the players to run through them.

Purpose: To practise lateral movement

Practice set-up: Two files of players face each other 16–20 yds apart with a maze of flag poles placed on the ground 3–5 yds apart and adjacent to each other. The first player moves forwards and runs from one side to the other, moving through the maze until he reaches the other side, whereupon the next player sets off in the other direction.

Equipment: Six flag poles

Progressions: The tempo can be increased, or one player from each side can compete with an opponent to see which one can reach the other file first. If two players compete, they need to be careful that they avoid each other as they race.

Purpose: Practice in stopping, starting, dodging, marking and changing direction at speed

Practice set-up: Players split up into pairs and work in a 12 yd square. Players are numbered 1 and 2 and one of them tries to escape the other who gives chase within the area. The player 'shadowing' the leading player does not actually touch him as they run; instead, he tries to keep as close to him as he can. The coach whistles regularly and all players must halt immediately when he does. If the 'chaser' can reach and touch his opponent, he gains a point; if not, the 'leader' gets the point. The chasers and leaders change roles after a set period.

Equipment: Four cones, two sets of coloured bibs

Progressions: After a set number of 'chases', the players count their points; to progress, the coach can change the pairs so that they work with other players.

drill 7

Purpose: General movement with changes of direction

Practice set-up: In an area 15 yds square, the players disperse and two players hold hands to form a 'chain' in the centre. The two players chase the others in the area and try to 'tag' them or force them outside the square. In either case, the tagged player joins the chain until one player is left. If the chain breaks at any time, then the other players are free to disperse and the original two players start again.

Equipment: Four cones

Progressions: Another two players have a turn and each two-person chain is timed to see how long they take to eliminate the others.

drill 8

Purpose: To practise feinting with the body

Practice set-up: Four to six players link hands to form a circle with one designated player in the group. Another player is the 'chaser' and stands a few yards away; all are in a circle 6–10 yds in diameter. The coach gives the command for the outside player to try and tag the designated player in the circle. The other players in the circle must hold hands without breaking free and move around in a circular fashion to avoid the designated player being 'tagged' by the chaser. Players keep changing roles so that they practise chasing and evading capture.

Equipment: A circle marked on the ground, one coloured bib

Progressions: Use more players holding hands so that the chaser has to move more quickly to touch the designated player. Each player can be timed and results compared at the end of the practice.

drill 9

Purpose: Change of pace and direction when running in all directions

Practice set-up: A group of players disperse in an area 15–20 yds square with two players that are identified by coloured bibs or shirts acting as the 'taggers'. The two of them chase the others, who try to evade them. Any player who is tagged must stand where he was touched with his arms outstretched to the sides and his legs wide apart like a scarecrow. The 'scarecrow' can come back into the activity if another team-mate manages to 'free' him by crawling through his legs without either of them being touched by the tagger in the process.

Equipment: Four cones, two coloured bibs

Progressions: The two players are timed on how long it takes to get everyone out in the group. Another two players then get their chance to beat the record.

drill 10

Purpose: To practise reactions and quick movement

Practice set-up: An area 12–15 yds square is marked on the ground with all the players standing on one line facing the coach and bibbed out in colours making 2–3 teams.The coach calls or points to a line and the last person to arrive at the line designated by the coach drops a point for his team. Scores are counted up at the end of the activity.

Equipment: Four cones, one to three sets of coloured bibs

Progressions: The coach can develop the drill by asking the players to run to the *opposite* line that he points to each time. He can change his call or point to another line at *any time* so that the players have to react quickly.

DRIBBLING AND RUNNING WITH THE BALL

Youngsters of between 7 and 11 tend to be somewhat oblivious of others around them as far as parting with the ball is concerned. They like to play with the ball and this should be encouraged, as the development of technical expertise is more important at this stage than learning when to dribble and when to release the ball – this will come later in the players' development. Experimentation, discovery and the repetition of a wide variety of running and dribbling movements with the ball at their feet should be a key aim for the coach.

Wayne Rooney, the teenage sensation, has made a meteoric rise from youth level to Everton and, ultimately, to representing England. He shows extraordinary skill, game knowledge and maturity for one so young, and continuous quality practice will ensure he fulfils his enormous potential. (Photo: Neal Simpson)

drill 11

Purpose: Running straight with the ball

Practice set-up: Two files of players stand facing each other and slightly to the side, 12–15 yds apart. Each file has a ball. The first player in the file proceeds to run smoothly with the ball in a straight line, and when he crosses the opposite line, the first player in the other file sets off with the ball at his feet in the opposite direction. Practise using both feet, increasing the tempo or lengthening the area so the players need to cover more distance with the ball.

Equipment: Four cones, two balls

Progressions: This drill can start with one ball only: if each player stops the ball with the sole of his foot when he reaches the line, the next player then sets off with it again. To progress the drill, players can run with the ball simultaneously from both ends until they finish a set number of repetitions – who finished first?

drill 12

Purpose: To run with the ball while changing direction quickly

Practice set-up: The group is broken into files of players who compete against each other via a slalom course marked with flag poles placed on the ground 1–3 yds apart. Each player in turn runs with the ball through the cones in a designated fashion decided by the coach (e.g. left foot only, alternate feet, a set technique or 'trick', etc.) before their team-mate takes over from the other side. Each player has to carry out a set number of runs and the first team to finish the course wins.

Equipment: Six to eight flag poles, two cones

Progressions: The tempo can be increased or the slalom can be made 'tighter' by placing the poles closer together to increase the difficulty of the drill.

Purpose: Passing on the run with the ball

Practice set-up: A long channel 15–25 yds long by 5–8 yds wide is marked on the ground and two small goals are made with cones placed 2 yds apart. Two files of players stand at the back of their respective goals. The first player runs with the ball and tries to pass it on the run through the small goal at the other end, continuing to run and join the end of this file. The next player receives this pass and runs with the ball to the other goal and so the drill continues. Keep a few spare balls around for continuity of the practice.

Equipment: Four cones, two balls

Progressions: Both teams racing against each other at the same time. Repeat the practice in the opposite direction so players have to use both feet.

Purpose: Dribbling and moving with the ball in all directions

Practice set-up: In the centre circle or a similar area, a group of 10–16 players dribble freely with a ball each and practise various tricks or movements. The players then try to 'tag' any other player while dribbling the ball, gaining a point for each player touched while still retaining control of their own ball. The players also avoid being tagged by dribbling with their ball quickly to get out of danger.

Equipment: One ball per player

Progressions: A competition to see which player finishes with the least number of touches in the time-limit given.

Purpose: To dummy or feint at speed

Practice set-up: Two files of players, each with a ball at their feet, stand facing each other 10–20 yds apart with a cone halfway in between them. One player from each side dribbles towards the other with their ball under control. As they get within a couple of yards of the other player they dummy to go left and then take the ball past their opponent on the right side. The players then join the rear of the opposite file as the next two players approach each other. The coach needs to make sure that the players start slowly before practising the designated skill. He also needs to ensure that the players are all using the same foot and moving to the same side so that they do not collide.

Equipment: One ball per player, one cone

Progressions: Increase the tempo as players' confidence grows, and practise more difficult skills while running with the ball.

Purpose: To dribble with the ball and evade challenges

Practice set-up: A group of 12–20 players with a ball each dribble inside the centre circle or a similar area. Each player moves with his ball under control. When one player in the circle temporarily loses control of their ball, another player tries to tackle and nudge the first player's ball out of the circle. The player who loses his ball then retrieves it and rejoins the game, while the player who knocked it out gains a point. Players count their points up at the end of the session. The player with the most points wins.

Equipment: One ball per player

Progressions: All players can also gain a point by forcing another player to run his ball out of the circle by dribbling a ball towards them.

Joe Cole, the diminutive Chelsea and England midfield player, is beginning to fulfil his early potential. Excitingly creative on the ball, he has the ability to wrong-foot opponents and create space for himself when none seems available, causing problems even for well-organised defences. (Photo: Mike Egerton)

Purpose: To practise using the inside and outside of the foot when running with the ball

Practice set-up: Eight cones are placed equal distances apart on the centre circle line. Eight players with a ball each at their feet stand at the cones, facing inwards towards the centre spot. On the coach's command, all the players run with their balls towards the centre before changing direction and doubling-back towards the next cone in a clockwise direction. The players run in sequence to the centre and then to the next cone, moving around the circuit. To increase difficulty, the coach can ensure that the players move in both directions, use both feet, speed up the tempo or practise set tricks or movements as they run with the ball.

Equipment: Nine cones, one ball per player

Progressions: As players dribble in one direction the coach can shout 'change' and the players must instantly move with the ball in the opposite direction.

drill 18

Purpose: To practise beating an opponent with the ball

Practice set-up: Two files of players face a defender in a channel 10–14 yds long by 6–10 yds wide. All the attackers have a ball each and the first one dribbles the ball forwards to play 1 vs 1 with the defender, who must stay on the centre line. The attacker tries to beat the defender and arrive with the ball at the far line. When the defender is back in position, the next attacker from the other side tries to beat him as before, and so the drill continues.

Equipment: One ball per player except the defender, four cones, one coloured bib for the defender

Progressions: The coach should set a time-limit of about one minute before changing the defender, as he will become easily tired. Each of the dribbling players has to fetch his own ball if the defender knocks it away.

Purpose: To dribble past a fast-approaching defender

Practice set-up: Two files of players face each other in a channel measuring 12 yds long by 18 yds wide. One file of players, the attackers, have a ball each. They emerge one at a time to engage a defender from the other side and try to get past him and run the ball over the far line. The defender can only move in a forward direction. After the action, both players move back to their respective files.

Equipment: Four cones, one ball between two players

Progressions: The attackers count how many points they have totalled before they become defenders. The two files compare total scores after the second file has finished attacking.

drill 20

Purpose: To dribble past defenders in changing circumstances

Practice set-up: In a circle measuring 20 yds in diameter, 5–6 small goals 1–2 yds wide are marked with cones. Ten to fourteen players with a ball each play against 3–4 players who act as defenders wearing coloured bibs. The attackers try to score a point by dribbling the ball through any of the small goals (from either side of the goal) while the defenders try to prevent them from doing so.

Equipment: Ten to fourteen balls, ten to twelve cones, three to four coloured bibs

Progressions: After a timed interval of one or two minutes, the scores are tallied to find the player who has dribbled through the most goals. The defenders then swap with some of the attackers so that all players practise dribbling the ball.

PASSING THE BALL

The development of sound, natural and efficient passing techniques is an important element for youngsters at this age. If bad habits are allowed to become a part of their kicking techniques, it will be much more difficult to remove them further along the line. Young players will find some drills more difficult than others because of the technical demands involved. Players in this age range have physical limitations as well as the psychological limitations due to lack of knowledge and experience. The coach needs to be patient and find the best way of giving the younger players in this age range early passing success in the more basic skills. Brute force is not required to kick the ball effectively – the drills will enable the youngsters to practise, learn and develop a range of basic passing skills. The coach's job is to get them to concentrate on a more natural, flowing and stress-free action when passing the ball.

David Beckham, the charismatic Real Madrid and England 'play maker', has made the transition from English- to Spanish-style soccer successfully. A tremendous all-round player, his passing skills particularly catch the eye. His dedicated practice as a boy has paid off with his mastery of this aspect of the game and his range of passing techniques and skills. (Photo: Mike Egerton)

Purpose: To practise short passing using the inside and outside of the foot

Practice set-up: Two files of players face each other 8–12 yds apart. The first player in one file proceeds to pass the ball directly across to the first player in the other file and then follows it; so the drill progresses. Each player controls the ball and passes it across to the opposite side ensuring that, as they run, they go wide enough to avoid blocking the line of the next pass.

Equipment: One ball

Progressions: Use both feet and various types of passes.

drill 22

Purpose: To practise various short passes with movement

Practice set-up: Two files of players stand facing each other 8–12 yds apart. The first player on one side passes the ball to the first player on the opposite side and immediately 'peels-off' to join the back of his own file. Each player receives and passes the ball in turn before rejoining the end of their file.

Equipment: One ball

Progressions: The coach can introduce two-touch, and eventually one-touch passing.

Purpose: To practise reverse passing with movement

Practice set-up: Three files are arranged in a triangular formation, each 8–12 yds apart. The first player in one file has a ball and proceeds to pass it to the next file, then follows on to join the back of that file. Each player controls and passes the ball in turn in a clockwise direction around the triangle, always following it to the next file.

Equipment: One to three balls

Progressions: The coach can introduce a second ball and third ball, both of which are passed around the triangle at the same time. He can also change the drill so the players pass in other directions and use varied passes.

Purpose: To practise short passing while moving backwards

Practice set-up: Players line up in pairs 2–4 yds apart, with two lines marked on the ground 15–25 yds away from each. One player in each pair has a ball and the player with the ball proceeds to pass it to the feet of his partner and they both move in the same direction, passing the ball between them. When they reach the line, they continue in the reverse direction so that both players practise passing in a forward and backward direction.

Equipment: One ball between two players, two cones

Progressions: Speed up the tempo of passing and use both feet.

Purpose: Short volley passing

Practice set-up: Two files of players stand facing each other 6–8 yds apart, with one player holding the ball in his hands. He gently serves the ball underarm to the player opposite while quickly moving out of the way and running to the end of the opposite file. The player receiving the ball passes it on the volley, cushioning it so the pass arrives for the next player to catch. He then moves to the back of the opposite file and so the drill continues, with one side tossing the ball while the other side passes on the volley.

Equipment: One ball, two cones

Progressions: Players practise using their weaker foot and serving the ball with spin, which is a more difficult skill.

drill 26

Purpose: To practise short passing with the inside and outside of both feet

Practice set-up: Four players with a ball each at their feet stand in a cross formation facing a fifth player, who stands without a ball in the middle. The players are 7–12 yds apart and the first player passes the ball to the central player for him to control and pass straight back. The central player then turns to the next player in rotation to receive a pass, and so the drill progresses for a set time interval or number of passes before changing places with another player.

Equipment: Four cones, four balls

Progressions: Change direction, feet and tempo of the drill by asking players to play first-time passes when they are able to do so.

Purpose: Short passing and movement

Practice set-up: Five players stand at the corners of a 7–10 yd square. Two of them stand together at one corner while the other three players position themselves at the other corners. One of the two players standing together has a ball and passes it to the player on the next corner while following on in the same direction to change places with him as that player controls and passes it on in turn. Each player controls and passes the ball while moving in stages around the square.

Equipment: Four cones, one ball

Progressions: Move in both directions, and groups can compete to see who can pass around the square quickest after a set number of circuits.

Purpose: Using alternate feet rhythmically to pass the ball

Practice set-up: Three players form a triangle 3–6 yds apart. One player without a ball faces two others who each have a ball at their feet. Both players pass alternately and continuously to the middle player who returns the passes first time in a rhythmical way, using his right and left feet.

Equipment: Two balls, one coloured bib

Progressions: Each player in turn has a set time or number of passes and the tempo of the passes should be gradually increased.

Purpose: To practise control and timing of short passes

Practice set-up: Four players form a cross in a 8–12 yd square. Two players have a ball and pass it directly to their partner opposite, who controls it before quickly passing it back. All the players need to keep their passing sequence going and avoid striking the other ball as they do so.

Equipment: Two balls, four cones

Progressions: Use both feet, varied techniques and increase the tempo to first-time passes when they are ready.

Purpose: Quick passing and control

Practice set-up: Four players stand around a 6–10 yd square, two of them with a ball at their feet. The two players with a ball proceed to pass the ball simultaneously in a clockwise direction around the square, so the balls rotate. At first, players should control the ball before passing it, but later they should try to pass the ball straightaway so that the balls are continually on the move.

Equipment: Four cones, two balls

Progressions: Use both feet in both directions.

Purpose: Short passing and ball possession

Practice set-up: Eight or more players link up by joining hands and outstretching their arms to form as wide a 'chain' as possible. One player stands in the centre. The outside players, without breaking their link, pass the ball between themselves so that the central player, who can only walk and not run, cannot get possession of the ball. The player who gives away possession of the ball by misplacing his pass changes places with the central player and becomes a defender who tries to intercept the ball as the others play 'keep-ball'.

Equipment: One ball, one coloured bib

Progressions: The players are only allowed one or two touches of the ball before passing.

drill 32

Purpose: Short passing on the move

Practice set-up: Six to ten players stand around the centre circle, or similar area, with two players who have a ball each at their feet facing them from the centre. The outside players jog around the circle in the same direction while the two central players, who stand a little apart from each other, pass the ball to each player in turn. The players give them a quick return pass, so that they pass around the circle in sequence.

Equipment: Two balls

Progressions: Pass in each direction, increase the tempo and change players' roles so that they all get turns in the centre and on the outside of the circle.

Purpose: Controlling and timing passes

Practice set-up: A cone is placed on each corner of a 10 yd square. One player stands in the middle, and four others stand on the outside of the four sides with one ball between them. The four players proceed to interpass, ensuring that they do not go inside the square, but that the ball passes through the square and inside their own cones each time. The middle player cannot leave his area, but tries to intercept each pass.

Equipment: Four cones, one coloured bib, one ball

Progressions: To increase the difficulty of the drill, the players can be restricted to two or three touches only. Alternatively, if their pass is cut out, they change places with the defender.

Purpose: Timing and selection of passes

Practice set-up: In a square 12 x 12 yds in area, four or five players play against one defender and try to maintain possession of the ball. The four players can move around anywhere in the area while the defender tries to intercept the ball.

Equipment: Four cones, one coloured bib, one ball

Progressions: The coach can impose conditions such as two touches only, or reduce the number of attackers, or even add another defender to increase the difficulty of the drill.

Purpose: Wall-passing

Practice set-up: Two files of players with a ball each stand 16–20 yds apart, and two players stand at the halfway mark 8 yds apart. The first player from one side plays a pass directly to one of the two central players, who relays it straight back to the passer while he is running to the other side. This player then controls the ball and runs with it to the back of the opposite file. The next player then repeats the process to the other central player, thus playing a 'wall-pass' in the opposite direction.

Equipment: Four cones, one ball per player, except the two central players

Progressions: The players can pass simultaneously so two players are 'wall-passing' from both sides at the same time.

SHOOTING AT GOAL

For youngsters this is a very exciting element of the game and one for which they need to learn the correct mechanics of kicking the ball. Young players naturally want to score goals, as indeed players of any age do. However, it is at this early age that the boy's peers, coaches or parents can unconsciously begin to put pressure on him to score and this will affect the development of his technique. This is often reflected by players 'tightening-up', which affects muscular co-ordination and can result in them trying to smash the ball out of the stadium, when in fact a calmer approach would have helped and allowed them to hit the target! The coach needs to help players to concentrate on smoothness and style when shooting at goal – the process is more important than the end result at this stage.

Ruud van Nistelrooy, the tall, rangy and supremely gifted Manchester United and Holland striker, is a goal scorer of the highest quality. He has demonstrated his ability to score goals from just about any conceivable situation and in a huge variety of ways. This is due to his nerve, range of technique and motivation to score goals – the ultimate striker's trademark! (Photo: Neal Simpson)

drill 36

Purpose: Shooting from a wall-pass

Practice set-up: A file of players with a ball each stands at the edge of the penalty area facing the coach who is 6–10 yds away. A goalkeeper defends the goal with two ball-retrievers stationed behind and to each side. Each player, in turn, passes the ball directly to the coach, who returns it directly to the right or left side so the player who has run on to the ball can shoot at goal. The player collects the ball from the retrievers and rejoins the end of the file as the drill continues.

Equipment: One ball per player

Progressions: Change the shooting angles and shoot from a greater distance.

Purpose: To practise short volley and half-volley shooting

Practice set-up: Two servers with a supply of footballs stand to the side of a goal with fixed nets. They are faced by a small file of players 4–8 yds away. The servers toss the ball underarm to each player in turn and the player hits a volley or half-volley into the net before returning to the back of the file. Servers should toss the ball at a fast pace to maintain the practice flow.

Equipment: A good supply of balls, a goal with a practice net

Progressions: Count the number of goals the players score in the empty goal in a timed interval or in a set number of services.

drill 38

Purpose: Quick reactions when shooting

Practice set-up: Two files of players face a goal 8–16 yds away, and defended by a goalkeeper. The coach is in a central position with a supply of balls. The first two players sit down and the coach serves the ball in between them so that they can recover quickly from their position. The first one to the ball gets to shoot at goal. They retrieve their ball as the next two repeat the process.

Equipment: A good supply of balls

Progressions: The coach can make the service more difficult or speed up the process.

Purpose: Shooting with the instep of the foot

Practice set-up: In a channel measuring 22 yds long by 10 yds wide a makeshift goal using flag poles is erected with a goalkeeper guarding the 'sticks'. One player stands at each end of the channel, one with a ball at his feet. The goalkeeper faces the player in possession of the ball, who shoots at goal. If the keeper saves the shot, he feeds it to the other player; if the shot goes past him, he turns to face the next shot.

Equipment: Two flag poles, four cones, one ball

Progressions: The players have a competition to see who scores most goals within a time-limit.

Purpose: To get in a shot against a recovering defender

Practice set-up: Two files of players stand in pairs 12–15 yds away from and to each side of the goal. One player has a ball and the other player, the 'defender', stands with his back to the goal with his legs apart. The player with the ball faces the defender and proceeds to push the ball through his legs, then runs around him quickly to shoot at the goal as the defender recovers.

Equipment: One ball between two players

Progressions: The players shoot from alternate sides and change over roles and sides after a timed interval so that everyone gets a taste of the action.

Purpose: To strike a moving ball at goal

Practice set-up: Two goals, defended by goalkeepers, are erected on an area measuring 14–20 yds long by 12 yds wide. The goalkeepers have a good ball supply in their goals. Two files of players stand next to each goal, but on opposite sides. The goalkeepers throw the ball simultaneously to the first player in the file on the opposite side. Each player controls the ball before passing it to the first player from the opposite file so they can shoot at goal. The two players then retire to the end of the file at the other side and the goalkeepers throw the ball to the next two players, and so the drill continues.

Equipment: Two portable goals, four cones, a good supply of balls

Progressions: Players can only shoot with the weakest foot or try to hit a certain area of the goal (e.g. low at far post).

Purpose: To shoot alternately with both feet

Practice set-up: Six to eight balls are placed in a line 1–2 yds apart and 8–14 yds from a goal defended by a goalkeeper. A line of players face the balls and the first player starts by running and striking the outside ball on the right with his right foot before quickly moving to strike the ball on his extreme left side with his left foot. He moves like a pendulum from the outside in until he has hit all the balls at goal.

Equipment: Six to eight balls

Progressions: Count the player's scoring ratio and how fast he achieves this, and compare it with other players.

drill 43

Purpose: Shooting from a narrow angle

Practice set-up: Six to eight balls are laid on the ground a yard apart and at an angle 8–14 yds from the goal. A file of players stands behind and to the side of the ball furthest from the goal. Each player runs to the line of balls and hits each ball in turn, moving down or up the line according to the coach's instructions, and looking to shoot all balls rhythmically and quickly. The coach can impose a time-limit, each player needing to take all shots within that interval. The player can use various techniques to score, such as out-swinging shots or swerved shots.

Equipment: Six to eight balls

Progressions: The drill is flexible, and the coach can ask the player to hit with one foot or both feet. The coach can number the balls so that the player needs to react at speed when the coach calls the numbers, in order to shoot at goal as quickly as possible.

drill 44

Purpose: To get in a shot while under challenge

Practice set-up: Two files of players line up 6–8 yds apart and 10–16 yds from a goal defended by a goalkeeper. The coach stands in a central position with a supply of balls and proceeds to pass the ball each time to one file, whose players look to get their shots in while the players from the other side give chase and try to prevent the shot. After a set period the players change roles. The coach should ensure that all players receive practice in shooting with both feet.

Equipment: A good supply of balls

Progressions: The service can be made more difficult for the player shooting by playing the ball nearer to the defender.

Purpose: Shooting in a variety of circumstances

Practice set-up: Four players each with three balls at their feet stand on the corners of a 12–16 yd square, with a player in the centre facing a goal defended by a goalkeeper. The players pass the ball in rotation for the central player to control and shoot quickly at goal. The players then switch positions after all twelve balls have been served so that a new player is given practice in the central position.

Equipment: Four cones, twelve balls

Progressions: The coach can make it more competitive by adding scores, only allowing first-time shots or asking the servers to toss the ball in the air for the central player to hit volleys or half-volleys.

drill 46

Purpose: To decide where to shoot at goal

Practice set-up: Two files of players stand opposite each other 10 yds to one side of the goal and 14–16 yds apart. The file nearest to the goal are the defenders; the file furthest from the goal are the attackers. The coach stands in front of the goal and in line with the file of attackers with a supply of footballs. He faces the file of attackers and passes to each one in turn. The attacker controls the ball and quickly runs with it to go around the coach and shoot as fast as he can. As soon as the coach passes the ball a defender moves to cover his goal line as the goalkeeper 'narrows the shooting angle' in front of him. Both players move back to their respective files and the drill continues.

Equipment: Two cones, a good supply of balls

Progressions: Change roles of attackers and defenders after a set period of time and encourage the attackers to assess the situation before deciding where to shoot. For example, the player may chip the ball over the goalkeeper's head, away from the covering defender.

Purpose: To shoot on the turn

Practice set-up: Two files of players stand to the side of each other 16–20 yds from a goal, with two flag poles placed in the ground a few yards in front. The players, who each have a ball at their feet, run forwards alternately at speed, going completely around the pole with the ball before shooting on the turn at goal. The players retrieve their balls as the next players come forwards to dribble the ball round the poles before shooting. Make sure players shoot as soon as they are coming out of the turn.

Equipment: Two flag poles, a good supply of balls

Progressions: Two teams can compete against each other within a time-limit to see who scores the most goals.

Purpose: To dribble and shoot

Practice set-up: Two players, an attacker and defender, stand in a channel in the penalty area 10–12 yds wide with six balls placed in the penalty arc. The attacker collects a ball and dribbles it past the defender to try and score. If he does they swap roles. The defender gets a ball and attacks while the attacker defends and they compete to see who can score most goals. If the defender wins the ball in the area he can go on to score; either way the players have alternate opportunities each time to defend or attack.

Equipment: Four cones, six balls

Progressions: The player with the ball must dribble past the defender before scoring; alternatively, two or more balls can be added to the practice.

drill 49

Purpose: Dribbling and shooting at goal

Practice set-up: On an area 20 yds long by 15 yds wide, two goals are erected and manned by goalkeepers. A small 'keepers only' semi-circle area is marked in front of each goal. Two files of players are bibbed out in two different colours to identify them and are numbered. The two teams sit behind a goal each and the coach calls a number and feeds a ball into the area. The two players play 1 vs 1 and try to beat their opponent and score. As soon as the coach calls a new number, the two players must leave the ball and return to sit behind their goals while the next two players compete.

Equipment: One ball, two sets of coloured bibs, two portable goals

Progressions: The team with the most goals wins.

Purpose: To dribble past a player before shooting

Practice set-up: A 15 yd square area is marked out with four goals positioned centrally on each side, which are defended by goalkeepers. Two adjacent goals are defended by goalkeepers from one team and two by goalkeepers from the other team. Two groups of six players in coloured bibs are split into two smaller teams that are numbered 1, 2, 3 and 4, 5, 6 respectively. Each team of three players sits behind their respective goals and opposite the opposing team with the same numbers. The coach calls two numbers, always an odd and even, and feeds a ball into the area. The four numbered players play 2 vs 2. Each pair has to defend their two goals and can score in either of the opposing goals. Whatever two numbers the coach calls, four players come out to try and score each time.

Equipment: Four cones, two portable goals, two balls, two sets of coloured bibs numbered from one to six (or as required)

Progressions: Count the goals scored within in a time-limit.

HEADING THE BALL

This is one of most neglected skills in the game and one that requires careful handling when presented to youngsters for the first time. Heading is hardly a natural technique – your first reaction is to shut your eyes and move your head out of the way of the ball as it approaches! It is vital in the early stages of their development for young players to feel confident that heading the ball will not be a painful experience.

For this reason, lightweight balls should be used, with the accent on fun and variety to alleviate any fears that youngsters have of heading the ball. The drills provided will enable the players to build up their technical expertise gradually before moving on to the more difficult skill of heading from crosses from the flanks.

Sol Campbell, the Arsenal and England central defender, is a dominating player for club and country. Tall, quick and powerful, he has a physical presence that he uses to good effect when attacking the ball in the air. Whether springing high to head out dangerous crosses from his goalmouth or, conversely, trying to score from 'set pieces' at the other end of the field, he excels in this part of the game. (Photo: Mike Egerton)

Purpose: Body power for heading

Practice set-up: A player sits on the ground facing his partner, who stands 3–6 yds away with a ball in his hands. The server tosses the ball gently underarm for the sitting player to return with a chest-high header, which the server catches. Players change positions after a set number of headers.

Equipment: One ball

Progressions: As the player improves, the server can throw the ball from a longer distance, so that more power and accuracy is required. The server can also move around to provide a moving target for the player heading the ball.

Purpose: Using the body to head the ball more effectively

Practice set-up: Two players face each other 3–5 yds apart, one standing with a ball in his hands while the other kneels on the ground. The server tosses the ball underarm, using both hands, for the kneeling player to return with a chest-high header. By denying the player the use of his legs when kneeling, he has to use his upper body more effectively to generate power to the ball. Players change positions after a set number of headers.

Equipment: One ball

Progressions: Move further away when serving so that the player has to utilise more power when heading the ball.

drill 53

Purpose: Diving header

Practice set-up: Two players face each other, one standing holding the ball and the other kneeling on the ground 4–7 yds away on soft ground or on a cushioned mat. The server tosses the ball underarm dropping it short of the kneeling player so that he needs to dive to head the ball. Ensure the player heading the ball uses both hands in front of himself to cushion his contact with the ground. The header should be played so that the server can catch it each time. Players change positions after a set number of headers.

Equipment: One ball

Progressions: The server can drop the ball even shorter or stand further away as he serves. Either way it will increase the difficulty for the other player.

drill 54

Purpose: Controlled heading

Practice set-up: A file of players face a team-mate who stands 3–5 yds away with a ball in his hands. The server tosses the ball underarm to the first player in the file, who returns it with an accurate header for the server to catch. The first player then crouches down while the server tosses the ball over his head for the next player in the file to head back and crouch down in turn. When he has moved along the file, the server joins the front of the file and the back player becomes the server. Proceed until everyone has had a turn.

Equipment: One ball

Progressions: Set up teams to compete against each other. Only headers that are caught by the server count.

Purpose: Heading for accuracy and power

Practice set-up: Using cones, set up two makeshift goals 4–6 yds wide and 5–7 yds apart. A player stands in the middle of each goal. One of the players tosses the ball up for himself and tries to score in the other goal with a header while the other player acts as a goalkeeper and tries to save the ball. He then serves himself and tries to score with a header. Players can score with a direct header from wherever they catch the ball. The drill should flow with headers and saves – count the goals to find the winner.

Equipment: Four cones, one ball

Progressions: Move the goals further away from each other so that the headers require more power. Allow players to head directly from an opponent's header either by diving or jumping to surprise the player.

Purpose: Jumping to head the ball

Practice set-up: Two files of players stand facing each other 3–5 yds apart and slightly to the side of each other. The first player tosses the ball underarm to the first player on the other side, then quickly turns and joins the back of his own file. The player receiving the ball jumps and heads it directly into the hands of the second player on the opposite file, then turns to run to the back of his own file. The sequence continues so that one file serves while the other heads the ball. Make sure that the balls are served high. Once the first player is back at the start, the files change over.

Equipment: One ball

Progressions: The files move further apart so that the players heading the ball have greater difficulty in judging the ball's flight and in maintaining accuracy.

drill 57

Purpose: Controlled heading

Practice set-up: The player gently tosses the ball to himself and heads it so that it rebounds from a wall for him to catch. He continues to feed the ball to himself, attempting to head it twice in succession before catching it and so on, increasing the number of headers by one each time. (Beware of standing too near the wall.) Ensure the player heads through the lower half of the ball.

Equipment: One ball, a high wall or a vertical rebound surface

Progressions: Each time the player practises he tries to beat his record score.

Purpose: Controlled and 'touch' heading

Practice set-up: A player faces a wall and gently tosses the ball high against it so that the ball rebounds. The player attempts to keep the ball in the air by repeatedly heading it against the wall. To improve control, the player should move closer to the wall until he can place both hands against it while still heading the ball rhythmically against the wall. (Beware of standing too near the wall.)

Equipment: One ball, a high wall or vertical rebound surface

Progressions: Start to move further from and then nearer to the wall while heading the ball, keeping control of it in the process.

Purpose: Heading for defending

Practice set-up: The player marks a line on a wall above his head. He faces the wall and either tosses the ball up to head it or tosses it underarm directly against the wall to head it. The player should start a heading sequence, counting only the headers which go above the line and try to beat his record.

Equipment: One ball and a high wall

Progressions: Players need to learn to head the ball high and away from the goal. Make the line on the wall higher – but not so high that players find it difficult to reach it with a header.

drill 60

Purpose: 'Touch' heading

Practice set-up: Two players stand 1–2 yds apart, one with a ball in his hands. He carefully tosses the ball upwards towards himself and heads it high and accurately for the other player to return with a header which the first player catches. This counts as two consecutive headers. The first player then repeats as before, however, the players now attempt three consecutive headers and the second player catches the ball. The players try to move up to 10 or more headers.

Equipment: One ball

Progressions: The two players move further apart so that greater accuracy is required when heading the ball.

Purpose: 'Touch' heading

Practice set-up: One player stands on his own, holding the ball. He gently and accurately tosses the ball upwards for himself and, keeping his head back, heads the ball skywards before catching it. He then tries to head it twice successively, then three times and so on.

Equipment: One ball

Progressions: Players continually try to beat their personal best score.

Purpose: Controlled heading

Practice set-up: Put up a 3–5 ft high long net or rope. A line of players pairs up on each side of it, with one ball between each pair. Each player with a ball starts by gently heading the ball over the net or rope for his partner to head back, so they can keep up a sequence. Later partners can pair up against other pairs (2 vs 2) on the same net. Place a mark on the ground to divide the area in half.

Equipment: One ball, two flag poles, a rope or net

Progressions: Each pair competes against another pair to see who can attain the highest heading sequence.

drill 63

Purpose: Controlled heading on the move

Practice set-up: Put up a net or rope 3–5 ft high and 1–2 yds wide. Two files of players stand on either side of it, facing each other, one file with a ball. The first player starts by tossing the ball across the net for the player opposite to head straight back over again for the next player opposite to catch. Both players – the thrower and the player heading the ball – run around the net to join the back of the opposite file as the drill continues.

Equipment: One ball, two flag poles, a rope or net

Progressions: Teams compete against each other and count their highest consecutive score.

drill 64

Purpose: Leaping to head the ball from a standing jump

Practice set-up: The coach, or a player, holds the ball in both hands high above the head of a player who is standing. The player underneath the ball springs up repeatedly, using both legs, to head the ball that is held by the coach. As they head the ball the players should tighten their neck muscles. After six jumps the player moves to the end of the file and the next player starts. The player holding the ball in the air can use a box to stand on if more height is needed.

Equipment: One ball, one box (if necessary)

Progressions: The coach holds the ball a little higher each time so that the player needs more spring to reach the ball.

drill 65

Purpose: Jumping to head the ball on the run

Practice set-up: Players stand in a file facing the coach, who holds the ball in both hands in the air. They run in sequence and jump using one leg to take off and head the ball, which is cushioned in the coach's grip. The player returns to the back of the file as the next player takes his turn.

Equipment: One ball

Progressions: The coach should hold the ball higher as the players' jumping ability increases.

drill 66

Purpose: To withstand body contact when jumping

Practice set-up: Two files of players stand side-on and a short distance apart. With the coach in front they keep in order and jog slowly forwards towards a cone 20 yds away. On the coach's command of 'Up!', they jump and make contact with the sides of their shoulders. When they reach the cone they jog backwards and then repeat the exercise.

Equipment: Two cones

Progressions: The coach must ensure the practice is safe and the contact between players is sensible.

drill 67

Purpose: Jumping to head the ball

Practice set-up: The coach faces a file of players standing 6–8 yds away. The coach feeds the first player with a high, soft and looping service and the player comes forwards, jumps and heads the ball back accurately before returning to the back of the file. The coach then serves continuously to each player in turn. He should keep some spare balls at his feet for misdirected headers.

Equipment: One ball (a few spare balls should be available)

Progressions: Throw the ball a little higher each time, so that the players need to improve their timing and increase their power when heading the ball.

drill 68

Purpose: Defensive power heading

Practice set-up: A file of players faces the coach from a distance of 3–5 yds, with two ball-retrievers facing the back of the coach behind a cone the same distance away. The coach tosses the ball to the first player who heads it high and long over the coach's head for one of the retrievers to catch. The player then turns and runs to the back of the file while the next player receives a service from the coach. Change the ball-retrievers often.

Equipment: Two cones, one ball (a few spare balls should be available)

Progressions: Increase the distances of the players and ball-retrievers from the coach to improve the power and distance when heading.

Purpose: Power heading in defence

Practice set-up: A coach stands facing a player who is 2–3 yds away. Behind the coach are a series of lines or cones set at yard intervals to represent distances. The first one is placed 1–2 yds behind the coach. A ball-retriever stands within the lines or cones to measure the distance of the headed ball. The coach serves the ball underarm and the player heads it as far over the coach's head as he can, getting points for the distance achieved. The ball-retriever returns the ball to the coach. The player gets six headers, totalling his score before changing places with the ball-retriever.

Equipment: Six cones, one ball

Progressions: Each player continually looks to improve his score.

drill 70

Purpose: Glancing headers

Practice set-up: Two servers stand at the sides of the goal with six balls each. The goalkeeper stands on the goal line while two players stand 6–8 yds in front and behind two cones in line with the goalposts. The servers alternately toss the balls gently underarm in a diagonal direction for each player to come and head at goal. After heading the ball the player runs towards the other cone as the next player receives service. The goalkeeper must stay on the goal line when defending the goal.

Equipment: Two cones, a good supply of balls

Progressions: Encourage the servers to make the practice more difficult by tossing the ball so the players need to jump high, or dive, to head the ball at goal.

CROSSING AND FINISHING

Although an integral part of the game, the techniques of crossing the ball and finishing off the resultant cross with a shot or header are difficult for young players to learn. With this in mind, the coach needs to be patient and aware of the potential difficulties so that he can guide the youngsters more sensitively through the drills.

Young players who can kick the ball reasonably well when striking it in a straightforward direction find it much more difficult to kick a ball on the move when they have to lift it up to a team-mate's head while running in another direction. The necessary balance, timing and co-ordination of several limbs needs much practice before the technique becomes refined. Equally difficult is the skill of moving on to a fast-approaching ball and timing it so that the player hits it on the ground, or in the air with a volley, or heads it at goal.

By using the drills and modifying them where necessary, such as allowing the players to cross a stationary ball, or by using a bigger or lighter ball, or controlling the cross before shooting, the players' confidence will grow and the coach can gradually increase the tempo as they progress.

drill 71

Purpose: Shooting from a cross

Practice set-up: A group of players are numbered from 1 to 5 or 6 with 1 acting as goalkeeper, 2 acting as the crosser and 3 shooting at goal from 10–16 yds, while the others form a file behind. Number 2 has a good supply of balls and proceeds either to play a ball along the ground or cross it in the air for number 3 to control and shoot at goal. All three players rotate so that 3 becomes the goalkeeper, 1 is the crosser and 2 joins the end of the file while 4 comes forwards to shoot.

Equipment: A good supply of balls

Progressions: Cross from both sides before shooting, or have the crosser position himself closer to the touchline, to increase the difficulty for the player shooting.

Purpose: Crossing and heading practice

Practice set-up: On an area 20 yds long by 30 yds wide, two goals are defended by goalkeepers. Two groups of three players stand at the halfway mark and two groups of three players stand in opposite corners. A server stands in the other two corners with a good supply of balls. The servers cross the ball to the corner groups in turn as they try to score. The four groups jog around the back of the goals and rotate around the area to continually meet the cross from the server for a set time-limit. All the groups add up their goal count.

Equipment: Four cones, two portable goals, a good supply of balls

Progressions: Keep changing around so that all players have equal opportunities to cross and head the ball.

drill 73

Purpose: Crossing to a specific area

Practice set-up: On an area measuring 20–24 yds long by 30 yds wide, two portable goals are positioned with a goalkeeper in each one. Two players acting as wingers stand in opposite corners with a good supply of balls. Two players acting as strikers face one goal each. A ball-retriever stands behind each goal. One winger crosses a low ball while the other crosses a high service each time so that each striker shoots or heads at goal before they turn and bypass each other to attack the other goal. They receive heading and shooting practice in this drill for a set interval before changing with other players.

Equipment: Four cones, two portable goals, a good supply of balls

Progressions: Players continually change their roles, acting as wingers, strikers, or ball-retrievers.

Purpose: Cutting the ball back on the move for a player to shoot

Practice set-up: A striker faces a goal 12–15 yds away which is defended by a goalkeeper. Two wingers stand 15–20 yds away from the goal with a good supply of balls. Two ball-retrievers are positioned behind the goal. The wingers run with the ball before cutting it back for the striker to finish with headers or shots. Depending on the type of service, the player can control the ball before shooting, volley the ball in the air, or head the ball at goal. The striker should change with another player after a set interval. The service should be regular.

Equipment: A good supply of balls

Progressions: The player cutting the ball back should be encouraged to run more quickly with the ball and to cross on the move, while the striker is allowed one touch to strike at goal.

drill 75

Purpose: Learning to time runs at goal and finish effectively

Practice set-up: Two portable goals, with goalkeepers, are positioned 10–15 yds apart, and two servers stand in opposite corners with a good supply of balls. Four pairs of players line up in files at the sides of each goal. Pairs of players come forwards alternately from each side to receive a thrown service from each server which they try to convert to goals. The pair perform a crossover run before receiving the service, and the server can vary the service by rolling it along the ground or tossing it higher for a header. The pair of players retires to the far file as the drill continues in the opposite direction. The goalkeepers must stay in their goal areas and not move forwards to stop the crosses.

Equipment: Four cones, a good supply of balls

Progressions: Ensure players continually change to get crossing and heading practice and eventually ask the servers to serve the ball by volleying it from their hands.

Purpose: Crossing and finishing in rotation

Practice set-up: Two portable goals are erected on an area measuring 20 yds square, both guarded by a goalkeeper. A supply of balls is left on the centre line on both sides. Two players run forwards with a ball from the centre line and cross the ball for two central players to shoot or head at goal. All players rotate one place so that they now cross, finish or await their turn to do so. A few ball-retrievers, or spare players awaiting their turn, can be used to ensure that the ball supply is maintained.

Equipment: Six cones, two portable goals, a good supply of balls

Progressions: The coach can ask the crossers to practise a particular type of cross (e.g. out-swinging cross, near-post cross, hard-driven cross etc.).

Purpose: Crossing a moving ball to the far post area and finishing the cross from that position

Practice set-up: A group of players organise themselves around a goal guarded by a goalkeeper. A server stands on the touchline with a supply of balls, faced by another player, the crosser, 10–15 yds away. A file of players stands at the other side of the goal. The drill proceeds with the server rolling a gentle pass for the facing player to cross. The first player in the file, the striker, breaks off and tries to finish with a shot or header. The players all rotate quickly.

Equipment: A good supply of balls

Progressions: The crosser moves to a wider position so that the cross becomes more difficult to perform.

Purpose: Crossing on the run, and timing runs to head at goal

Practice set-up: Two portable goals are placed 15–20 yds apart, each with a goalkeeper. There are three files of players at both ends: two files of players act in pairs and stand to one side of a goal; the other file stands 15–20 yds away from the other side of the goal in a marked channel. The wider files of players have a good ball supply at both ends. The drill starts with one player running with the ball along the channel while a pair of players runs parallel and centrally, competing to receive his cross and to try and score. All players join their respective files at the other end and the drill continues in the opposite direction. The files should change over so that they both get crossing and finishing practice.

Equipment: Four cones, two portable goals, a good supply of balls

Progressions: The coach can ask the players to run with the ball a little faster to add an edge to their crossing techniques.

Purpose: Crossing with both feet, and timing runs to head at goal

Practice set-up: Two portable goals are placed 15–25 yds apart on a goal line, each defended by a goalkeeper. Two servers are positioned on the goal line and 10–15 yds away from their respective goals. The player who is crossing the ball stands between the servers 6–10 yds away. Two strikers are positioned in each of the far post areas of the goals. The drill starts with server 1, who is on the right side of one goal, rolling a gentle pass for the player in front to cross with his right foot to the left. Striker 1 attempts to score from this cross. The player crossing the ball immediately turns to face a service from server 2 and hits a cross with his left foot to the opposite side. In this way he receives practice on both feet. The tempo should be increased, and the players should switch roles regularly to practise crossing and finishing.

Equipment: Two portable goals, a good supply of balls

Progressions: The coach can ask the player crossing the ball to aim for specific areas, e.g. near a goal post.

Purpose: Selecting where to cross the ball and finishing while under challenge from opponents

Practice set-up: On an area measuring 20 yds long by 30 yds wide, two teams play 4 vs 5 or 5 vs 5 with two portable goals, each defended by a goalkeeper. Two wingers, one on each side of the field, stand outside the area. Two teams of players play normal football and when the attacking team gets near a goal, they pass the ball to either of the wingers. The winger receiving the ball must try to cross the ball for another player on the same team, who attempts to score from the cross. Play restarts with the other team having possession and playing the other way.

Equipment: Four cones, two portable goals, one or two balls, coloured bibs

Progressions: The coach can count the number of crosses in the game, or the number of goals scored, and award points to the team that has amassed the highest total.

GOALKEEPING

All youngsters should experience this specialist position, which is so unlike any other in the team. As the only player who can use his hands to stop the ball, many of the skills and techniques the goalkeeper needs to learn differ greatly from those needed by outfield players. The goalkeeper has a special responsibility in the team as the 'last line of defence' and can help his team win by making match-winning saves. The goalkeeper not only needs to become a good 'shot-stopper' and deal with crosses, he also is the 'first line of attack' in his team and needs to know how to throw and kick the ball accurately to start off attacking moves for his team. The drills provided are geared to the specifics of goalkeeping and they will give 'would-be' goalkeepers practice in the relevant skills of the position.

Fabien Barthez, the France goalkeeper, has, like many top-class keepers, developed his own unique style of playing the position. Good keepers need to learn the defensive part of the game, such as shot-stopping and dealing with crosses. In attack, they now have a bigger part to play, and need to be able to kick, pass and throw effectively in the modern game. (Photo: Panoramic)

drill 81

Purpose: Correct diving techniques

Practice set-up: The goalkeeper lies on his side along the ground, with his chest facing the coach. The coach rolls the ball along the ground to one side of the goalkeeper. The goalkeeper pushes along the ground to catch or direct the ball away. He then returns to his position and repeats the action. The coach should repeat the exercise a set number of times, but should take care not to exhaust the goalkeeper.

Equipment: A good supply of balls

Progressions: Gradually extend the goalkeeper's skills by rolling the ball a little further from him, or by rolling it a little faster, so that his technique is put under continual but controlled pressure.

drill 82

Purpose: Recovery and diving technique

Practice set-up: The goalkeeper sits on the ground faced by the coach who has a ball in his hands. The coach serves the ball to the side of the goalkeeper, who dives sideways to catch it and return it to the coach for the next service. The coach serves the ball six times to the right side and then six times to the left side.

Equipment: A good supply of balls

Progressions: The coach should gradually extend the goalkeeper by throwing the ball a little higher or further from him and alternately left and right as the session progresses.

Purpose: Correct diving technique

Practice set-up: The goalkeeper kneels on one knee and faces the coach, who holds a ball. The coach proceeds to toss the ball to one side of the goalkeeper, who dives to catch it and return it to the coach. (Note: the toss should be to the side where the knee is off the ground.) The coach should ensure that the goalkeeper is diving along the side of his body, so that he can see the ball clearly and use the softer part of his body to land.

Equipment: A good supply of balls

Progressions: Gradually extend the goalkeeper by serving the ball faster or further from his body so that he needs to react more quickly or improve his diving techniques.

Purpose: Catching the ball from a cross

Practice set-up: A file of goalkeepers faces the coach, who stands to the side 13 yds away. The coach serves a high, looping throw for each goalkeeper in turn. Each goalkeeper must move and jump to catch the ball as high in its flight as possible before returning it to the coach and going to the back of the file. The goalkeeper needs to be aware of his timing and should try and come a little late so that he gathers momentum and arrives to take the ball in a forward direction.

Equipment: A good supply of balls

Progressions: The coach can stand further away and either use a javelin service or kick the ball from his hands. This increases the difficulty for the goalkeeper, who has to assess the flight of the ball and catch it at the top of his jump.

Purpose: Punching the ball from a cross

Practice set-up: A file of goalkeepers stands in front of and to one side of the goal. The coach, who has a good supply of balls, stands on the other side of the goal and further back. The coach serves a ball to each goalkeeper and they take turns to punch the ball high and far away from the goal, using either one hand or both. (Note: ensure children use a safe technique and wear goalkeeper gloves.) The coach should make sure that young goalkeepers watch the ball's flight carefully and punch right through the bottom part of it so that the ball travels far and high out of the danger area.

Equipment: A good supply of balls

Progressions: The coach stands at various positions on the flank and delivers a more realistic and difficult service for the goalkeeper to deal with.

Purpose: Positioning and shot-stopping

Practice set-up: Two players pass the ball between them in a channel 12–18 yds wide in front of the goalkeeper. They pass quickly and shoot within 1–3 passes. The goalkeeper gets practice in changing his angle and position to face each shot. A supply of balls keeps the practice flowing and the coach should ensure that the pair of players continually attack the goal, thus keeping the goalkeeper under pressure. The goalkeepers should change every three or four minutes so they can recover.

Equipment: A good supply of balls, six cones

Progressions: The coach can encourage the players shooting at goal to try and use as many varied techniques as possible to give the goalkeeper more realistic practice in positioning and stopping their shots.

Purpose: Practising quick reactions, positioning and shot-stopping

Practice set-up: One or two players stand behind 6–8 footballs, positioned 13 yds from the goal. The goalkeeper stands off his goal line. The player starts at the end ball and shoots in sequence as the goalkeeper reacts quickly to save each shot. The next player lines up the balls and shoots starting from the other side, moving to hit each ball in sequence until he has fired all six to eight shots at goal.

Equipment: Six to eight balls

Progressions: The player shooting at goal can strike any ball at random so that the goalkeeper has little time to react and has to move his feet and take the correct angle for the different shots. Thus he will need to make the best out of every situation in order to protect his goal.

Purpose: Correct diving technique

Practice set-up: A file of goalkeepers stands in the centre of the goal with a ball each in their arms. One at a time, they jog with the ball towards the coach, who stands in front in the penalty area. The coach points to the left or right and the goal-keeper dives with the ball while on the move, rolling over and recovering with the ball still in his hands. He then returns to the back of the file, awaiting his turn to repeat the action.

Equipment: A good supply of balls

Progressions: The coach can encourage the goalkeepers to dive a little higher and help them to land more effectively by getting their body into a comfortable shape and relaxing the muscles not actually used in the action.

drill 89

Purpose: To gather a ball rolling along the ground

Practice set-up: The goalkeepers stand in a file facing the coach, who is 6–10 yds away. The coach serves the ball, with his feet or hands, along the ground for the first player to come forwards and gather the ball. The goalkeeper then uses a bowling action to roll the ball back to the coach before quickly returning to the end of the file. In this way, each goalkeeper receives fielding practice.

Equipment: One ball

Progressions: The coach can ask players to speed up play, or can roll the ball to the sides of the goalkeepers so that they have to employ better footwork.

Purpose: To catch a hard-driven ball at chest level

Practice set-up: Four files of players stand 8–10 yds apart in a cross formation. Two leading players on adjacent files hold a ball in their hands. The players throw the balls forcefully towards the chests of the players opposite, who catch them and throw them back to the next players in the files. After throwing the ball, players join the end of the file to await their turn.

Equipment: Two balls (a few spare balls should also be available)

Progressions: Speed up play or serve the ball to the sides of the player (though not too far away) to incorporate better footwork and catching practice.

Purpose: Fielding a ball rolling along the ground

Practice set-up: The players stand in pairs, 3–8 yds apart. One holds the ball and faces his partner. Two lines are marked on the ground behind them to show the practice area. (Alternatively, cones can be used.) The player with the ball dribbles it along the ground, slowly driving the other player, the goalkeeper, backwards. The goalkeeper either controls the ball with his feet or gathers it with his hands and returns it quickly to the oncoming player until they reach the line. They then reverse roles and direction until they reach the opposite line and then repeat the drill.

Equipment: Two cones, one ball

Progressions: Speed up play or use various fielding techniques, such as going down on one knee, or keeping the feet together and a straight back to cup and scoop the ball up into the goalkeeper's arms from the ground.

Purpose: Positioning and shot-stopping

Practice set-up: A portable goal, defended by a goalkeeper, is erected using two cones, and a pair of players stands 10–12 yds away on both sides of the goal. One ball is shared between all the players. The players are allowed a maximum of three passes before shooting from behind the line. If the goalkeeper saves, he rolls the ball to the other pair; if the shot goes past him, he turns quickly to face a shot from the other side. In this way, the practice alternates from end to end.

Equipment: Six cones, one ball (keep a spare ball handy)

Progressions: The coach can ask the players to hit a specific type of shot (e.g. high in the corner or low and hard at the goalkeeper's body), thus giving the goal-keeper more realistic practice.

Purpose: Quick reactions, agility and shot-stopping technique

Practice set-up: The goalkeeper stands on a soft surface facing a wall or shooting board 3–6 yds away. The coach, or a player, stands behind and slightly to the side of the goalkeeper and serves the ball by hand or foot so that it rebounds from the wall. The goalkeeper sees the ball coming late and has to react or dive quickly to catch it. He rolls it back to the coach and gets ready for the next service.

Equipment: One or two balls, a rebound surface

Progressions: The coach can feed the ball a little harder or wider, or the goal-keeper can move a little closer to the wall so that there is less time for him to react to the oncoming ball.

drill 94

Purpose: Various shot-stopping situations and throwing the ball

Practice set-up: Two portable goals (preferably with nets) are erected 10–16 yds apart, and are defended by two goalkeepers who have a good supply of balls. Each goalkeeper tosses the ball, in turn, from just in front of their own goal line, trying to score in the other goal. The other goalkeeper tries to save the ball and, in turn, throws the ball towards the far goal, and so the drill continues.

Equipment: Two portable goals, a good supply of balls

Progressions: The goalkeepers can throw the ball harder to give each other better quality practice, or the coach can ask them to serve the ball in a particular way (e.g. low or lobbing the ball under the crossbar) to give them practice at handling specific shots.

Purpose: Angling, positioning, shot-stopping and distribution

Practice set-up: Two portable goals (preferably with nets) are erected 10–16 yds apart, and each is defended by a pair of goalkeepers, who have a good supply of balls. One goalkeeper throws or kicks the ball towards the opposite goal to try and score. The goalkeepers take up appropriate positions to save the ball each time, and take turns to shoot at goal.

Equipment: Two portable goals, a good supply of balls

Progressions: The goalkeepers can strike the ball at goal much more aggressively. This not only gives their opponents valuable practice, but also improves their own kicking techniques, which all good goalkeepers require in the modern game.

WARMING DOWN

The drills that are always done at the conclusion of the coaching session are used to help the players, who have been working hard physically and mentally, to return the body and mind to its normal state. This period should always be entertaining for young players so that they will want to come back for more, which is why small-groups, light-hearted activities and competition are used. The main function is not the development of skills, although obvious errors can be quickly pointed out, but to finish the session in a gradual fashion and to have some fun and social interaction in the process.

Ronaldo, the magical Real Madrid and Brazil striker, is a player with awesome skill, pace and goal-scoring instinct. Blessed with a powerful physique, he has developed the good habit of warming down at the end of each practice or competitive match to allow his body to recover properly. (Photo: Nigel French)

drill 96

Purpose: For fun, competition and to return the body to its normal state

Practice set-up: Four files of players stand behind four hoops 10–12 yds apart. Twelve balls are placed in the centre. One player from each team runs to collect a ball in his arms and carries it back to place it in his hoop. The next player from each team does likewise and so the drill continues until one team has four balls in their hoop. During the drill, each player is allowed to go and steal a ball for his hoop from another team's hoop instead of from the centre, if it is advantageous for his team.

Equipment: Four hoops, twelve balls

Progressions: Add more balls.

Purpose: For fun, competition and to return the body to its normal state

Practice set-up: Four files of players stand behind four hoops as in drill 96, and aim to get four balls inside their hoop to win. However, instead of using their hands to carry the balls, they must dribble the ball. The same rules as in drill 96 apply. Players are not allowed to kick other balls as they practise. However, as before, they can steal another ball by dribbling it from another hoop back into their own.

Equipment: Four hoops, twelve balls

Progressions: Add more balls.

drill 98

Purpose: Light running, competition and some flexibility work

Practice set-up: Teams compete against each other in files of players who face a cone 10–12 yds away. The front player has a ball under his arm and he proceeds to run around the cone and back to his file. He turns his back and passes the ball over his head for the rest of the file to do likewise until the ball reaches the back player, who receives the ball and repeats the drill. Each player in turn runs with the ball and passes it overhead along the team for a set number of repetitions, which is decided by the coach.

Equipment: One cone and one ball per team

Progressions: The players can perform different movements as they run to and from the file of players (e.g. side skips, running backwards, forward rolls).

drill 99

Purpose: Fun, competition and helping the body to recover

Practice set-up: Teams line up in files facing a marker 10–15 yds away. The front player has a ball at his feet and proceeds to run with it at speed around the marker. He then returns to his file, where the remaining players stand with their legs wide apart to make a tunnel. The player passes the ball through the tunnel so that the back player stops it and proceeds to run with it around the marker. The coach sets a number of repetitions for each team.

Equipment: One cone and one ball per team

Progressions: The coach can ask each player to use different skills when running with the ball (e.g. left foot only, alternate feet, or having a player complete a full circle with the ball around the cone before returning with it to his team).

drill 100

Purpose: Fun and warming down activity

Practice set-up: Files of players form a chain by each one holding the bottom of another's training bib or shirt at the back. The first player in the chain has a ball at his feet and, on a diamond shape 10 yds wide at each marker, he proceeds to run with the ball, keeping it under control just in front of himself as the chain moves in unison with him around the diamond. When they reach the starting point again, the first player goes to the back and the exercise is repeated. The chain must not break, otherwise the players must start again.

Equipment: Four cones, one set of coloured bibs, one ball

Progressions: A heavier medicine ball can be used, or the players can be told to move in both directions around the square.

Purpose: Heading and general warming down

Practice set-up: Four players, each holding a ball in their hands, stand beside a cone in a 10–15 yd square. One player stands beside a cone placed in the centre. The central player runs to each of the other players to receive a gentle underarm throw in the centre which he must head back for each player to catch. After each header, the player has to touch the centre cone before moving clockwise around the square. He performs a second circuit, but during the second circuit he runs *around the back of each player* that he heads the ball to each time, so that he finally completes eight headers in all.

Equipment: Five cones, four balls

Progressions: The central player, if the coach wishes, can be asked to perform various skills, such as passing from the ground, volleying the ball or controlling the ball before he passes.